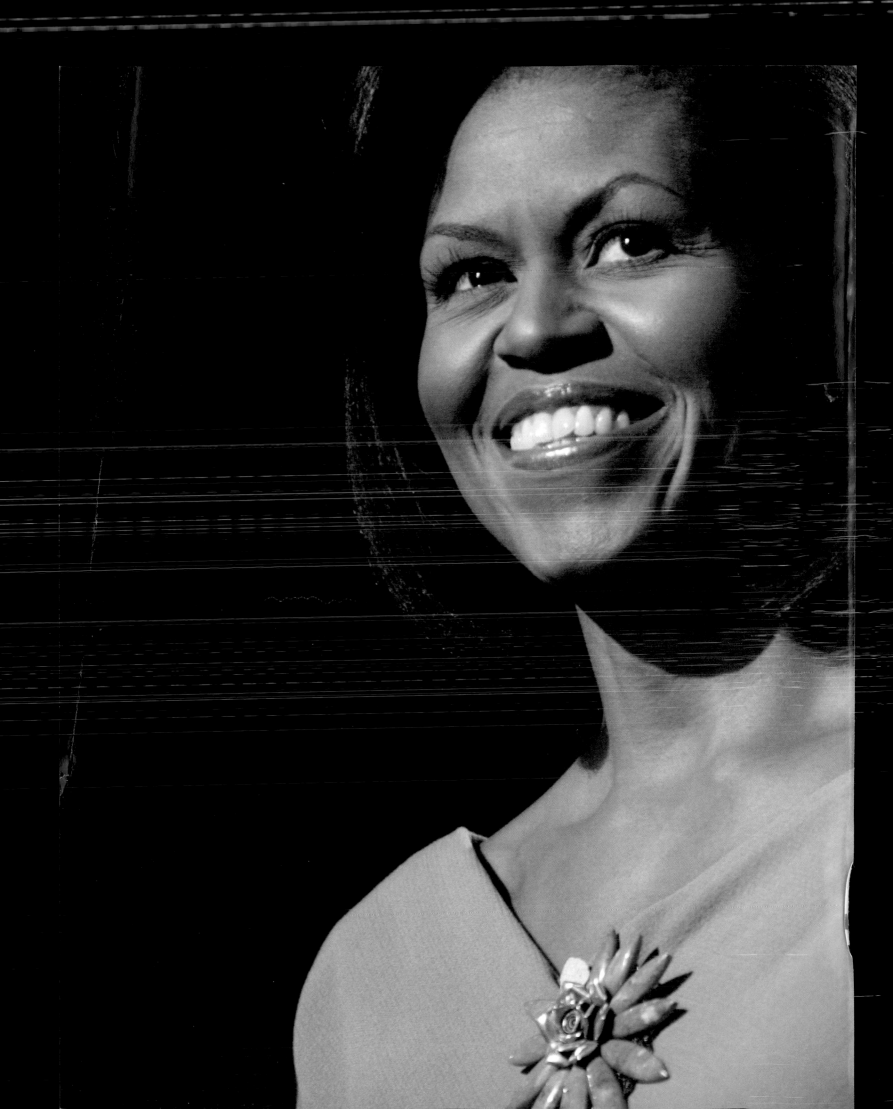

A Portrait
of the First Lady
MICHELLE OBAMA

A Portrait
of the First Lady

MICHELLE OBAMA

THE EDITORS OF **LIFE**

LIFE Books

EDITOR Robert Sullivan
DIRECTOR OF PHOTOGRAPHY Barbara Baker Burrows
CREATIVE DIRECTOR Mimi Park
DEPUTY PICTURE EDITOR Christina Lieberman
CHIEF OF REPORTERS Hildegard Anderson
SENIOR WRITER Danny Freedman
COPY Barbara Gogan (Chief), Cheryl Della Pietra,
Danielle Dowling, Heather L. Hughes, Parlan McGaw
CONSULTING PICTURE EDITORS Sarah Burrows,
Mimi Murphy (Rome), Tala Skari (Paris)

PRESIDENT Andrew Blau
BUSINESS MANAGER Roger Adler
BUSINESS DEVELOPMENT MANAGER Jeff Burak

TIME INC. HOME ENTERTAINMENT
PUBLISHER Richard Fraiman
GENERAL MANAGER Steven Sandonato
EXECUTIVE DIRECTOR, MARKETING SERVICES Carol Pittard
DIRECTOR, RETAIL & SPECIAL SALES Tom Mifsud
DIRECTOR, NEW PRODUCT DEVELOPMENT Peter Harper
ASSISTANT DIRECTOR, BOOKAZINE MARKETING Laura Adam
ASSISTANT PUBLISHING DIRECTOR, BRAND MARKETING Joy Butts
ASSOCIATE COUNSEL Helen Wan
BOOK PRODUCTION MANAGER Suzanne Janso
DESIGN & PREPRESS MANAGER Anne-Michelle Gallero
BRAND MANAGER Shelley Rescober

EDITORIAL OPERATIONS Richard K. Prue (Director), Brian Fellows (Manager),
Keith Aurelio, Charlotte Coco, John Goodman, Kevin Hart,
Norma Jones, Mert Kerimoglu, Rosalie Khan, Patricia Koh,
Marco Lau, Brian Mai, Po Fung Ng, Lorenzo Pace, Rudi Papiri,
Robert Pizaro, Barry Pribula, Clara Renauro, Donald Schaedtler,
Hia Tan, Vaune Trachtman, David Weiner

SPECIAL THANKS Glenn Buonocore, Susan Chodakiewicz, Lauren Hall,
Jennifer Jacobs, Brynn Joyce, Robert Marasco, Amy Migliaccio, Brooke
Reger, Ilene Schreider, Adriana Tierno, Alex Voznesenskiy,
Sydney Webber, Jonathan White

Want more pictures of Michelle?
Please visit the special gallery
at our dynamic new interactive Web site:
LIFE.com/michelleobama

PAGE 1: *Michelle Obama speaks on her husband's behalf
during a campaign event in Manchester, New Hampshire,
on June 2, 2007.*
BROOKS KRAFT/CORBIS

PAGES 2–3: *Michelle Obama smiles during her keynote address
to the Democratic National Convention at the Pepsi Center
in Denver on August 25, 2008.*
SONYA HEBERT/DALLAS MORNING NEWS/CORBIS

THIS PAGE: *First Lady Michelle Obama and her husband,
President Barack Obama, dance during the Western Inaugural Ball
in Washington, D.C., on January 20, 2009.*
CHIP SOMODEVILLA/CORBIS

CONTENTS

MOMENTS
IN A JOURNEY

ALREADY A LEADER

Michelle Robinson, in her 1981 yearbook photograph. She is remembered by former classmates as having been very popular and well respected at the Whitney M. Young Magnet High School, where she was elected student council treasurer. Her academic achievements gained her admittance to Princeton University.

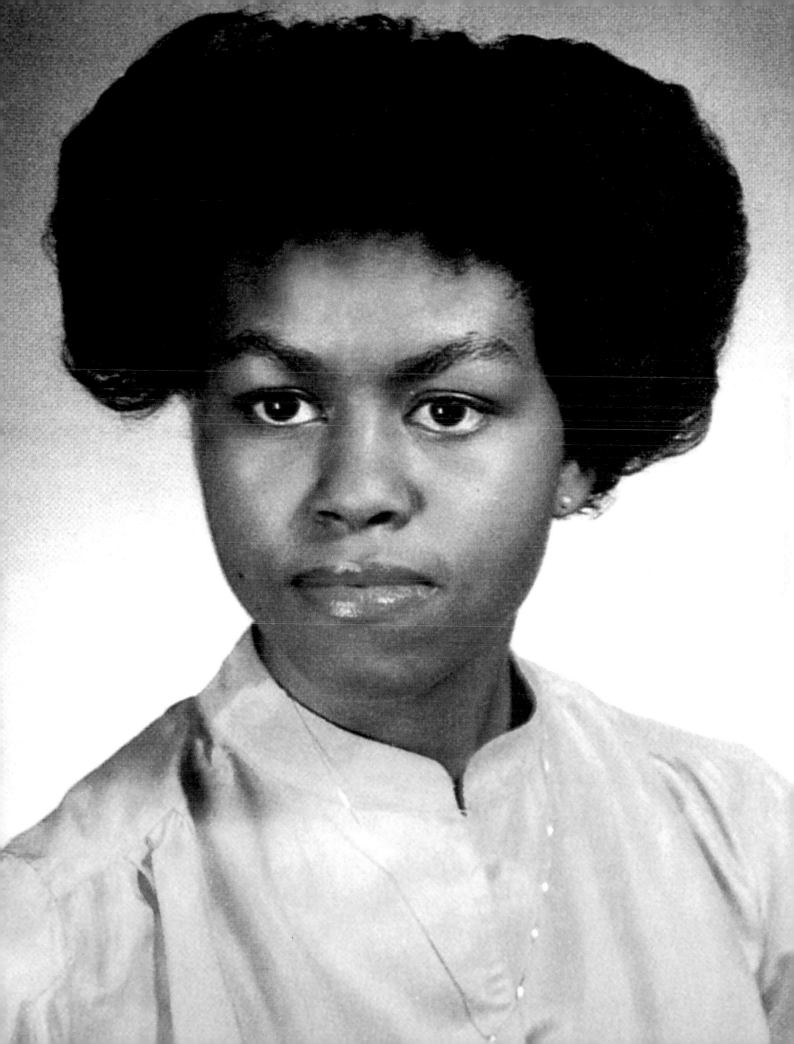

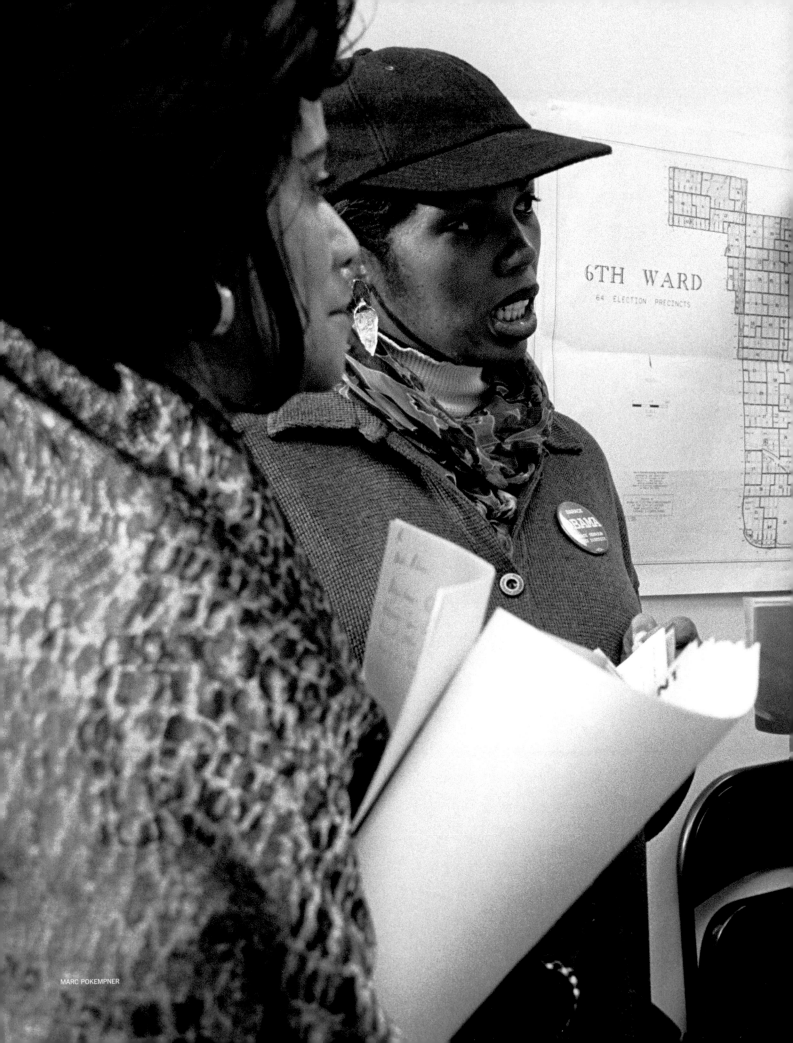

6TH WARD

64 ELECTION PRECINCTS

JUGGLING CAREERS

In 1996, Michelle Obama was spending days working as executive director of the Chicago chapter of Public Allies, a nonprofit that grooms young people for public service jobs. Whatever free time she had was spent helping with her husband's first political campaign—a run, which would prove successful, for the Illinois Senate. Here, she strategizes at the Obama campaign headquarters.

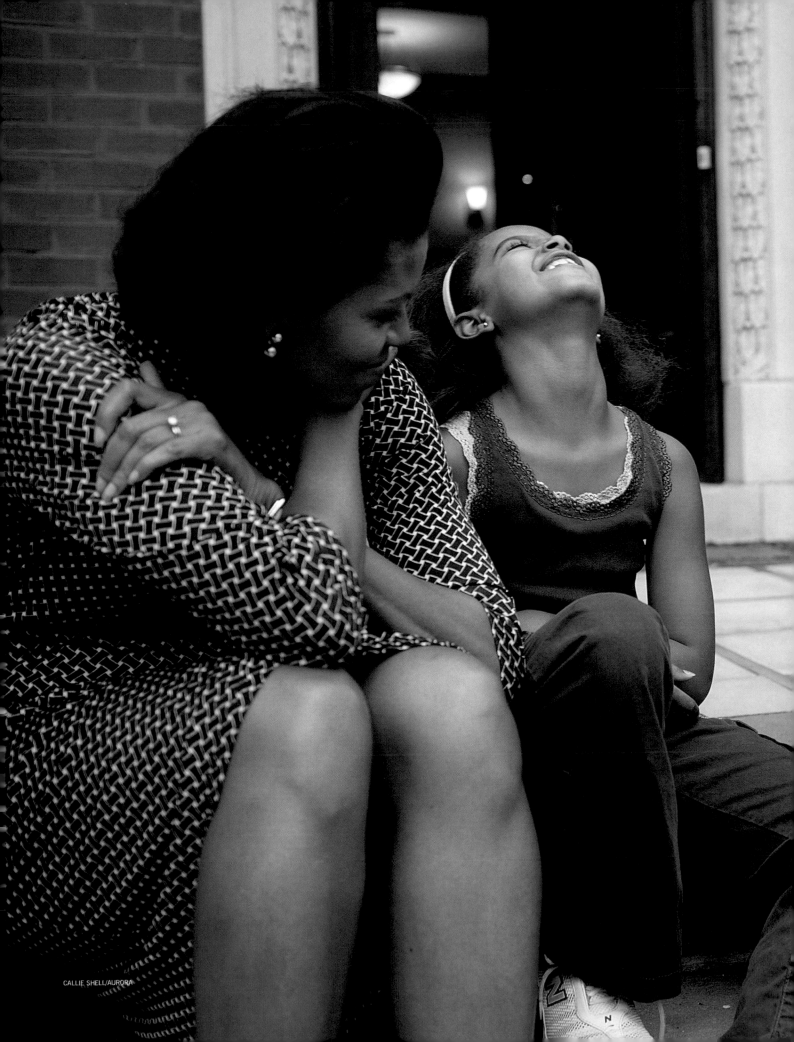

BUILDING A FAMILY

In October 2006, Michelle, daughters Malia (left) and Sasha, and husband Barack relax on the front steps of the family's Georgian Revival mansion in Chicago's Kenwood district. At this time, Dad's job in the U.S. Senate often keeps him in Washington, D.C., but Michelle remains a working mother in Chicago, where the girls go to school.

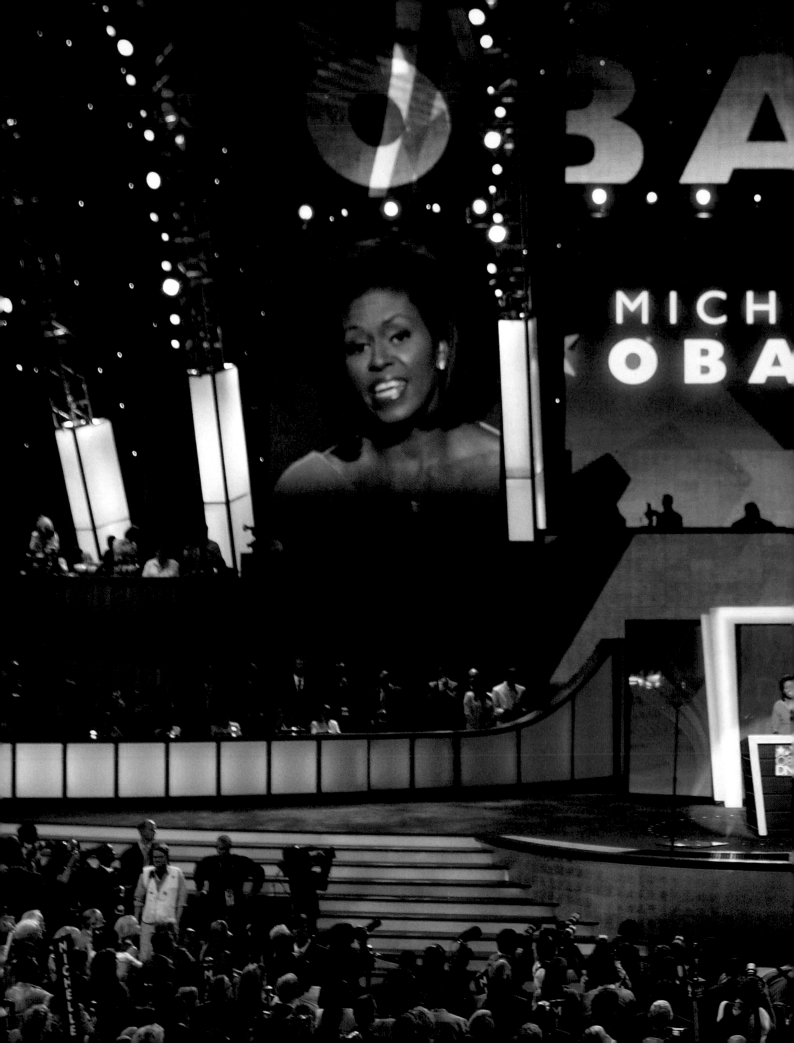

On August 25, 2008, Michelle Obama delivers the first major address to the Democratic National Convention in Denver, imploring the delegates to "fight for the world as it should be," so that one day their children "will tell their own children about what we did together in this election. They'll tell them how this time, we listened to our hopes instead of our fears. How this time, we decided to stop doubting and to start dreaming."

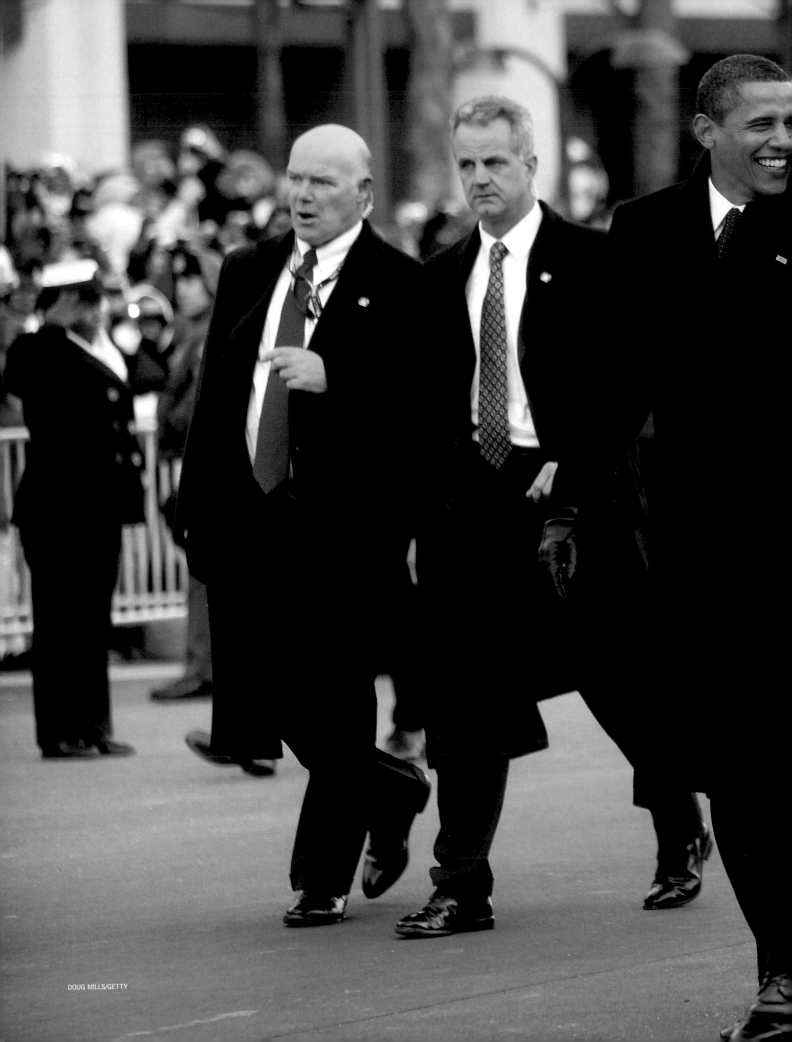

VICTORY MARCH

On January 20, 2009, the newly inaugurated 44th President of the United States of America and the nation's 46th First Lady walk the parade route down Pennsylvania Avenue to the White House. Earlier, during the swearing-in ceremony, Michelle had held for Barack the Bible that was used by Abraham Lincoln when he became President in 1861.

LIFE PARTNERS

Barack and Michelle Obama hold hands at the Biden Home States Inaugural Ball on their first night as the country's First Couple. They will attend no fewer than 10 official balls during the evening: the Neighborhood Ball, the Obama Home States, the Youth, the Commander-in-Chief's, the Mid-Atlantic, the Western, the Midwest, the Southern, the Eastern and the Biden Home States.

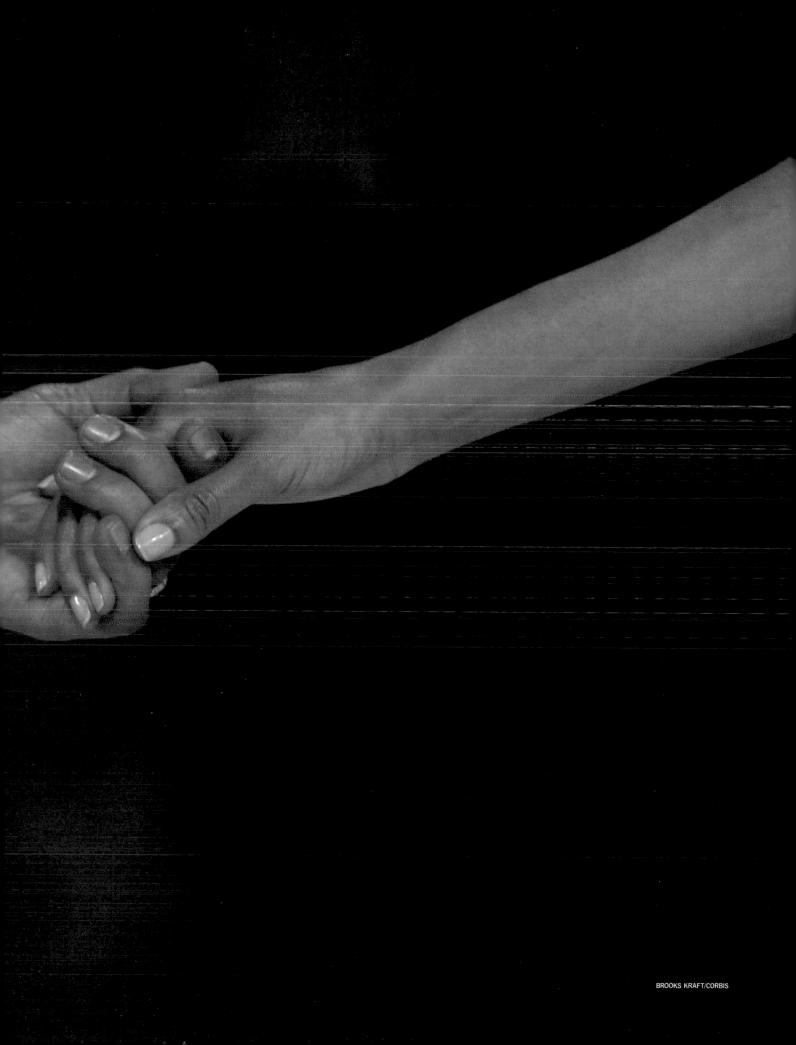

INTRODUCTION

L AST SUMMER, WHEN WE AT LIFE BOOKS WERE PUTTING TOGETHER OUR VOLUME *The American Journey of Barack Obama,* we were struck, of course, by the exoticism and improbability of his story: the birth in Hawaii to an African father and the descendant of early European settlers; the handicap of growing up in modest circumstances with just a mother; the years in Indonesia; the identity crises of adolescence; the maturing young man, finding himself in the halls of academia; the neophyte activist and politician in Chicago;

the supernova senator from Illinois, and then. . . . Well, as we wrote in the introduction to the revised, postelection edition of that book: "Whenever a new President of the United States is elected, history is made. But never has it been made so dramatically as it was on November 4, 2008, when America's voters chose Barack Obama to lead our country for the next four years. To say the election was unprecedented is to downplay its significance. This was a watershed at the least. Perhaps it was an earthquake."

Who, after all, could not be struck by such a story?

In researching that narrative, however, we came to be deeply impressed not just by Barack Obama but also by the life and personality of the woman who would enter the White House at his side. Here was another inspiring family story: the son and daughter of a municipal worker leaving home to be educated in the Ivy League, both destined for achievement in their chosen fields. While Michelle's older brother would rise as a college basketball coach, she would return home with her degree from Harvard Law School to join a high-powered firm. The work there did not provide the satisfaction she was seeking, so she left to embark on a succession of jobs in which she gave her energy to help the urban community. In 2008, her husband would famously champion "change," but for several years already, Michelle's watchwords had seemed to be "reaching out" and, always, "commitment."

Along with most Americans, we learned a lot about this woman during the campaign: her determination, her seriousness of purpose, her intelligence, her sense of humor, her extraordinary energy, her candid nature, which sometimes caused her problems in a political world. We learned from Barack's second volume of memoirs, *The Audacity of Hope,* about her dedication to daughters Malia and Sasha, and that it was Michelle who was the glue in the family. As we were putting the wraps on our earlier book about the President, one of the conclusions we had reached, as voiced at the office water cooler, was: "One thing's for sure—the guy married well."

He did indeed. And as we saw the strength that Michelle exhibited in the campaign's late stages and witnessed the way the country was responding to—succumbing to—her charisma and evident authenticity, we determined that there was a second book to be done. This would be a book with a new story and new pictures presented from a very different angle.

Once the Obamas had ensconced themselves in Washington, D.C., they (all four of them, but Michelle in particular) did nothing but reinforce the soundness of our decision. They went out and about—working, playing, *doing.* An obviously attractive First Family, they were the camera's friend, and vice versa. This is no small issue when planning a LIFE book.

Michelle Obama almost instantly became an American icon—a role model in such diverse pursuits as public service, parenting and even backyard gardening; and a trendsetter in the country's approaches to fitness and fashion. Her tastes were well matched to a nation being challenged economically, and it was an often-made observation that she was as pitch-perfect a First Lady of Style as any since Jacqueline Kennedy. Women everywhere were heading for the gym to get their arms in shape for those simple, elegant sleeveless dresses.

Her can-do attitude and her backstory were also just right for trying times. As the pictures and narratives on the pages that follow will prove, Michelle's is a story of achievement every bit as substantial as her husband's. Every bit as substantial . . . and inspiring.

Here, then, is the American journey of Michelle Robinson Obama, from a rented apartment in Chicago's Hyde Park neighborhood to a position in Washington as the 46th First Lady of the United States. The rise of this woman, as will be evident in this book, is a journey that, while already exciting to behold, has only just begun. —THE EDITORS

Michelle cracks up while talking with a voter at Cafe Mississippi in Guttenberg, Iowa, during her husband's campaign for President.

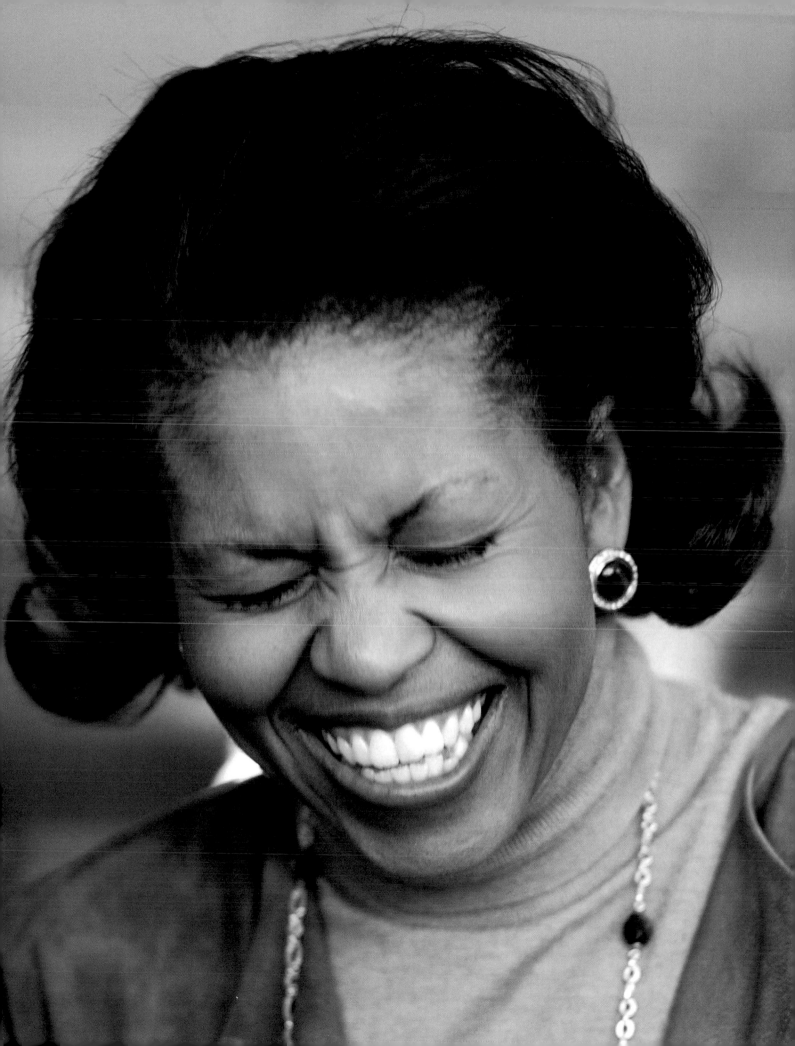

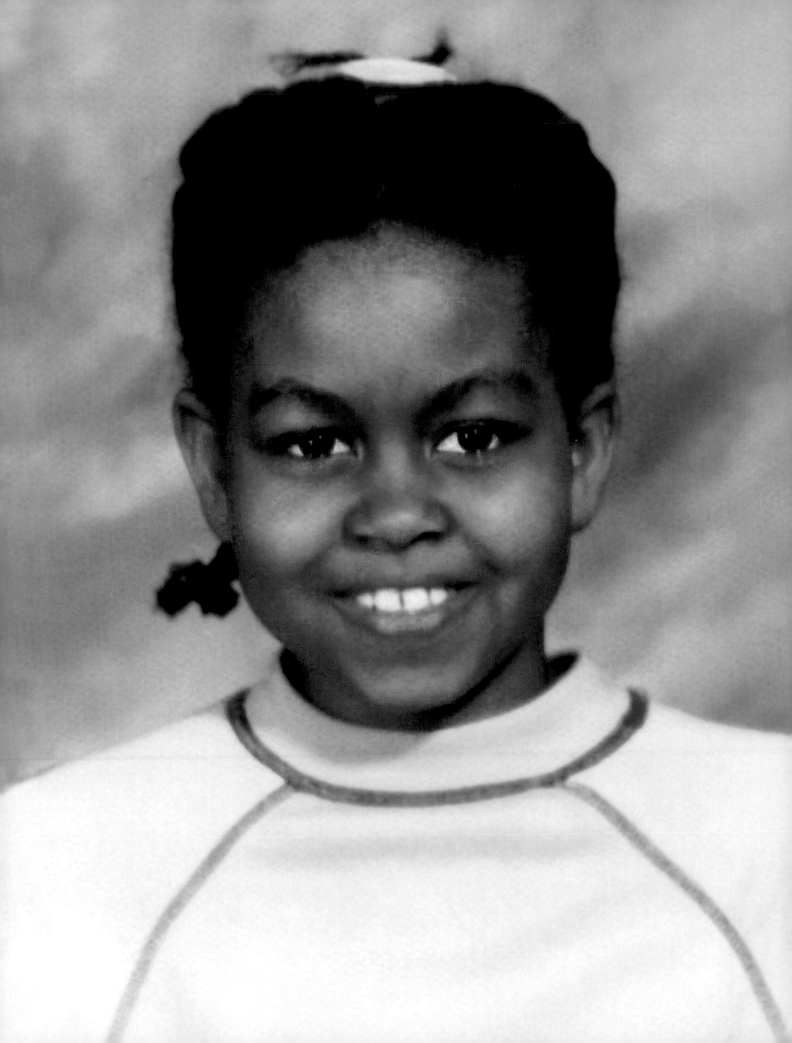

MICHELLE ROBINSON

I T WAS A BLUSTERY WINTER'S DAY IN Chicago—January 17, 1964—when Michelle LaVaughn Robinson came into the world. She was the second of two children born to Fraser Robinson III and Marian Shields Robinson. Both parents were natives of Chicago's South Side, where they would raise their children and where Michelle would continue to live and be a part of the community until her move out of town—that coming in early 2009 to a magnificent mansion at the esteemed address of 1600 Pennsylvania Avenue, Washington, D.C.

Michelle's parents represent a heartening American story in and of themselves. Fraser's great-grandfather was a South Carolina slave. Although debt forced Fraser to forgo higher education, he worked to send his younger brother to college. After marrying in 1960, he began a lifelong career in the Windy City's water department, his work on boilers and pumps providing for his wife and children. Marian cared for the kids at home during their school years and later took a secretarial job at a bank.

Michelle lived with her family in a rented top-floor apartment of a brick bungalow on Euclid Avenue in the increasingly black South Shore neighborhood. At home, Marian constantly reinforced an atmosphere that prized education and encouraged her children to aspire—to be thinkers, doers, decision makers. The Robinsons told their kids to "respect your teachers, but don't hesitate to question them," Marian recalled in a 2008 article in *The New Yorker*. "Don't even allow us to just say anything to you. Ask us why."

Michelle as a young girl during her days at Bryn Mawr Elementary (now Bouchet Academy), a public grade school in Chicago's South Shore.

Fraser had an affable nature, and the atmosphere at home was warm, nurturing—and downright fun. "It turned out that visiting the Robinson household was like dropping in on the set of *Leave It to Beaver*," wrote a regular visitor named Barack Obama in his 2006 book, *The Audacity of Hope*. "All that was missing was the dog. Marian didn't want a dog tearing up the house." While there may have been no barking, the rooms were filled with laughter and the music of jazz records, and with old yarns being spun by any number of local aunts, uncles and cousins who would come by.

This is not to imply that the Robinsons were all about froth and frivolity. Fraser and Marian sought to instill a sense of personal duty in their children at an early age. The kids were given alarm clocks when they started kindergarten and were responsible for getting themselves up in time for school. (Michelle's strategy to catch a few extra *zzz*'s turned into a daily ritual: She had her brother, Craig, nearly two years her senior, wake her when he was finished with the bathroom.) If there was any misbehavior during the day, Fraser could end it with a stern look and two curt words: "I'm disappointed."

"You never wanted to disappoint him," Michelle told *Newsweek* in 2008. "We would be bawling." On another

occasion she said of her late father: "I am constantly trying to make sure that I am making him proud." And she elaborated further on Fraser's continuing influence: "That's the voice in my head that keeps me whole and keeps me grounded and keeps me the girl from the South Side of Chicago, no matter how many cameras are in the room, how many autographs people want, how big we get." Fraser worked—without a grumble, his children have testified—even as he struggled with the debilitating effects of multiple sclerosis, which eventually forced him to walk with two canes. In 1991, he headed to work, despite not feeling well, and died along the way, at the age of 55. His children were successful young adults by then—Michelle was 27—and they could fully appreciate the man's contributions to whom they had become. Both parents "poured everything they had into me and Craig," Michelle has said. "It was the greatest gift a child could receive: never doubting for a single minute that you're loved and cherished and have a place in this world."

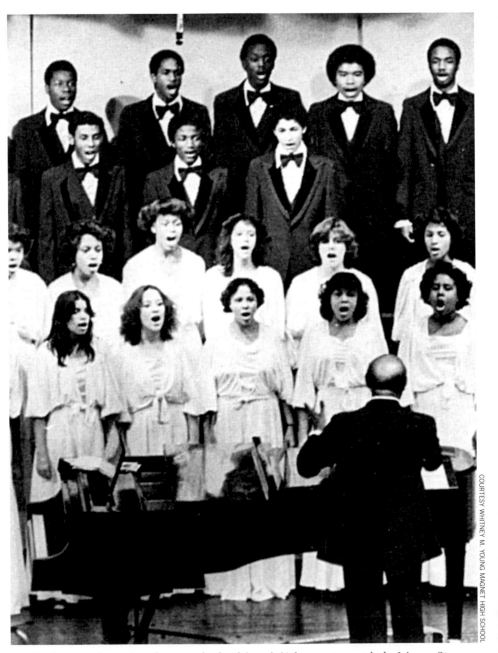

Michelle (second row from bottom, third girl from left) harmonizes with the Master Singers in 1980 during her junior year in high school.

Family accounts all hold that young Michelle could be willful, a force to be reckoned with. Her mother had taught Craig to read at an early age and confidently set about teaching Michelle as well. Her daughter paid her no attention at first, figuring she could handle the challenge herself. Michelle did become a precocious reader—before she started school, in fact—but the incident is illuminating.

Craig remembers that the siblings, whose bedrooms were carved from the apartment's living room by a divider, would play a game there that they called "office." "She was the secretary, and I was the boss," he recounted to *Vanity Fair.* "But she did everything. It was her game, and I kind of had nothing to do."

The Robinson kids relished a rare trip to the circus and pizza on Fridays. They had to make do with only an hour of TV per night (and yet, Craig has recalled, Michelle "somehow managed to commit to memory every single episode of

The Brady Bunch"), but they weren't complainers. They were also not troublemakers, though they were not above getting up to mischief if the end justified the means—an example being their attempts to dissuade their parents from smoking cigarettes by removing the tobacco or by lacing the butts with hot sauce. Michelle perhaps should have remembered that gambit years later when she was struggling to get her famous husband to kick his own cigarette habit.

In school, Michelle had some difficulty taking tests but made up for this by immersing herself in her work with characteristic fervor. "I always say Michelle raised herself from about nine years old," her mother once told the *Chicago Tribune*. "She had her head on straight very early." Michelle eventually rose to the top echelon of her school's gifted program from the sixth through eighth grades, and that performance led to acceptance to a public magnet high school. There she served on the student council and was inducted into the National Honor Society.

As Michelle approached graduation from high school, her smart basketball-star brother was already at Princeton University. Michelle was told at her school that the Ivy League would be a reach, but she wasn't discouraged and took her shot. Princeton said yes, and in 1981, Michelle joined Craig on the idyllic New Jersey campus. Craig was happy to see his strong-minded sister arrive, of course, while reporting back to the folks in Chicago that she hadn't changed a bit. "Mom, Michelle's here telling people they're not teaching French right," he complained at one point to Marian, who offered this sage motherly advice: "Just pretend you don't know her."

The Robinsons stood out at Princeton, and not just because of Craig's considerable basketball prowess (he was twice named Ivy League Player of the Year). Fewer than 10 percent of Michelle's freshman class was African American, and some black students at the time found the atmosphere chilly—or even colder. One of Michelle's first roommates at the university, a girl from the South, was moved to another room after her mother, having learned that Michelle was black, demanded that the school intervene. (Michelle was apparently unaware of the incident at the time.) A quarter century later, the mother told *The Boston Globe* that she regretted her decision, and in fact was considering voting for Barack Obama for President.

"Of course, it was different, being black," Michelle told *The New Yorker*, "but I found a black support base for myself. It was also different not being filthy rich. At the end of the year, these limos would come to get kids, and me and my brother would be carrying our cardboard boxes down to the train station."

In her four years at Princeton, the feeling that she was an outsider never completely dissipated. For her senior thesis, the sociology major (with a minor in African American studies) decided to investigate changes over time in the racial identity and attitudes of the university's black alumni. "My experiences at Princeton have made me far more aware of my 'Blackness' than ever before," she wrote. "I have found that at Princeton, no matter how liberal and open-minded some of my White professors and classmates try to be toward me, I sometimes feel like a visitor on campus, as if I really don't belong. Regardless of the circumstances under which I interact with Whites at Princeton, it often seems as if, to them, I will always be Black first and a student second."

Michelle also wrote that, although she had always envisioned herself working to better the black community, she had noticed her goals gradually shifting into alignment with those of her white classmates: moving on to a top-notch graduate school or to success in big business. This was problematic. She could, she wrote, be headed into a limbo, a life perpetually "on the periphery" among whites, with her ties to the black community loosened.

In any event, she made a decision and, having graduated with departmental honors, continued on immediately with her education, at Harvard Law School. "Princeton was a real crossroads of identity for Michelle," Harvard Law professor Charles J. Ogletree, Michelle's adviser, told *The Boston Globe*. "The question was whether I retain my identity given by my African American parents, or whether the education from an elite university has transformed me into something different than what they made me. By the time she got to Harvard she had answered the question. She could be both brilliant and black."

At Harvard Law School, Michelle distinguished herself as a diligent worker of quiet resolve and as a person who gave generously of what little spare time she had. Carrying on the search she had begun at Princeton, she helped the Black Law Students Association round up black

Harvard Law alumni to share their real-world experiences with students. And in the basement of the building where Barack Obama would soon after be given the editorship of the prestigious *Harvard Law Review*, Michelle worked some 20 hours a week in the school's legal aid bureau. In this operation, budding lawyers helped shepherd the poor through civil cases, like landlord-related disputes and family law matters. Ronald Torbert, a co-worker at the legal clinic, told Michelle's biographer Liza Mundy, for her book *Michelle*, "I remember being struck almost immediately by—although she smiled a lot and we had a lot of fun—[how she had] a serious side to her, the things she thought about. . . .

"If there's one thing that stood out about her," Torbert continued, "she is not easily impressed. You think you're working hard, and I think her attitude is: 'Well, that's what you're supposed to do.'"

Michelle graduated in 1988; to mark the occasion, her parents paid to have a message printed in the back of the yearbook. It was short and semisweet: "We knew you would do this fifteen years ago when we could never make you shut up."

After law school, Michelle accepted a job offer from the firm Sidley Austin, where she had previously spent a summer interning, and returned home to Chicago. An interesting historical footnote: In the intellectual property group, among several mundane tasks, she worked on the firm's account for Barney, the purple dinosaur. For some reason, this wasn't stimulating enough for her, and she complained up the ladder about the assignments she was being handed. Her department head at the time, Quincy White, later told biographer Mundy that he and another partner discussed the matter and came to the same conclusion: that Michelle was complaining that she was being treated like a second-year associate. "[A]nd we agreed that she *was* a second-year associate."

White added: "I couldn't give her something that would meet her sense of ambition to change the world."

Not everything at Sidley Austin was of limited interest to Michelle in those first several months. One rainy day in mid-1989, for instance, a young man arrived who was interesting in the extreme.

"Who names their kid Barack Obama?" That was among the skeptical thoughts turning around in Michelle's mind when she heard the buzz about the bright, young—and, yes, cute—Harvard Law student who would be in her charge as a summer intern. She didn't know whether she would be getting a nerd or an arrogant and insufferable bore—but she figured it would probably be one or the other. "He sounded too good to be true," Michelle recalled to author David Mendell for his biography, *Obama: From Promise to Power.* "I had dated a lot of brothers who had this kind of reputation coming in, so I figured he was one of these smooth brothers who could talk straight and impress people.

"So we had lunch," she continued, "and he had this bad sport jacket and a cigarette dangling from his mouth, and I thought: 'Oh, here you go. Here's this good-looking, smooth-talking guy. I've been down this road before.'"

Well, no, she hadn't, as things turned out. The more Michelle and Barack talked in the coming days, the better they connected. They shared their thoughts on the need for social change. They discussed his exotic background, which intrigued her—a biracial Hawaiian, after all, who had spent part of his childhood in Indonesia (where life had included a pet ape named Tata, among other curios). She learned of his pre-law-school gig in Chicago: three years as a community organizer in the hard-pressed neighborhoods just south of where Michelle had grown up. He made her laugh.

And she made him swoon. At that very first lunch, amid Michelle's talk of plans for future success (and no time for being sidelined by men!), he had seen, as he wrote in *The Audacity of Hope,* "a glimmer that danced across her round, dark eyes whenever I looked at her, the slightest hint of uncertainty, as if, deep inside, she knew how fragile things really were, and that if she ever let go, even for a moment, all her plans might quickly unravel. That touched me somehow, that trace of vulnerability. I wanted to know that part of her."

And so he asked for a date. She balked, citing a technicality: How would it look for a supervisor to be out with her supervisee? But Barack would remain resolute in his pursuit. One day, he invited her to a community-organizing session in the basement of a South Side church. Innocent enough, and a turning point. Michelle later recalled Barack speaking movingly that night to an assembled group of mostly single parents and caretaker grandparents. He addressed, she said, "the world as it is, and the world as it should be," and argued that community organizing could be a tool to shrink

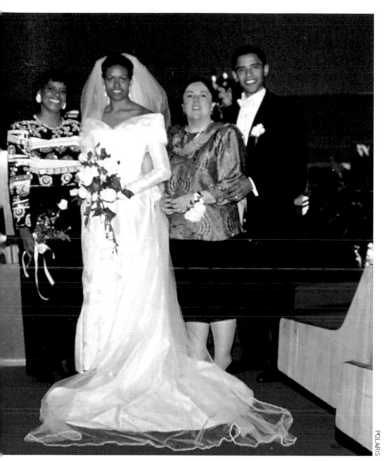

POLARIS

On October 3, 1992, proud mothers Marian Robinson and Ann Dunham pose in Chicago with their newlywed offspring, Michelle and Barack Obama.

the space in between. "And he connected with every single person in that room," she remembered. "There were a lot of 'Amens' going on. So I thought, 'This guy is pretty special.'"

About a month after they met, Barack finally got his date—unofficially. "We won't call it a date," Michelle told him. "I'll spend the day with you." They went to the Art Institute of Chicago and then to the Spike Lee movie *Do the Right Thing*. They finished with drinks at a bar overlooking the Chicago skyline. Some nondate that was. Michelle had been, she later admitted, swept off her feet. When Barack met Spike Lee years afterward, he thanked him personally.

Michelle brought Barack home to meet the family. They were duly impressed but wondered how long it would be until the poor guy was dropped; Michelle had already dumped more than a couple. But Barack hung around,

saying all the right things, passing all the tests she threw at him. "He's one of the few men I've met who is not intimidated by strong women," Michelle told the *Chicago Tribune* in 2007. "He relishes the fact that I'm not impressed by him."

In one oft-told anecdote, Michelle asked her brother, Craig, to see what Barack was like on the basketball court. Their dad had often said that much could be learned about a person in the arena of sport. Craig obliged, nervously. "My sister didn't have many long-term boyfriends," he wrote years later in an essay for *Time* magazine. "So I was thinking, 'This guy seems like a pretty good guy; I hope he makes it.' I was rooting for him." Barack played well enough, but more important, he was confident, he genuinely wanted to win and he was a team player. Craig told Michelle after the workout, "Your boy is straight, and he can ball."

After Barack graduated magna cum laude from Harvard Law in 1991, he proposed marriage. The lady said yes. All seemed right with the world.

But during this time, Michelle suffered two devastating losses: A close friend from college passed away, and so did her father. These tragedies in quick succession pushed Michelle to reassess her life. She realized she didn't really know what she wanted to do in the law and questioned whether she was contributing anything to the world—or, at least, to her city. She decided to make a move. Michelle left the law firm for a $60,000-a-year position at City Hall as an assistant to Mayor Richard M. Daley. In a meeting that, in hindsight, would prove important to both Michelle and her future husband, she had interviewed for the position with the mayor's deputy chief of staff, Valerie Jarrett, who was a key mover and shaker in Chicago's black community (and is today a senior adviser in the Obama administration). Jarrett was impressed by Michelle and offered her the job on the spot.

The following year—on October 3, 1992—Michelle Robinson and Barack Obama were married at Trinity United Church of Christ, where they were both congregants, in a ceremony officiated by the Reverend Jeremiah A. Wright Jr.

At the time, most of the country beyond Chicago hadn't heard of any of these people—Valerie Jarrett, the Reverend Wright, Barack and Michelle Obama.

That, of course, was destined to change.

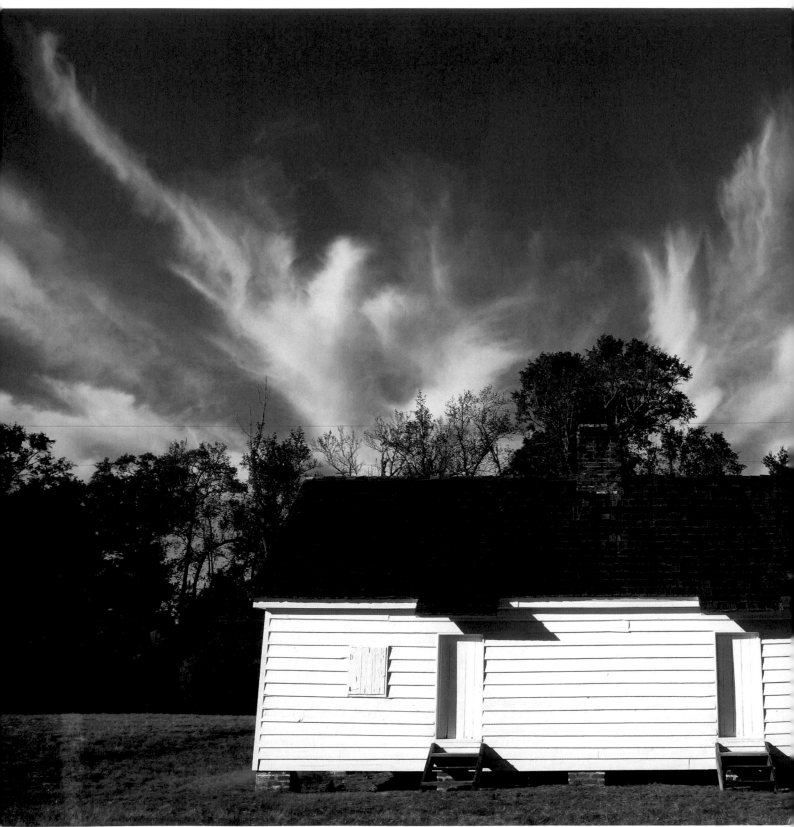

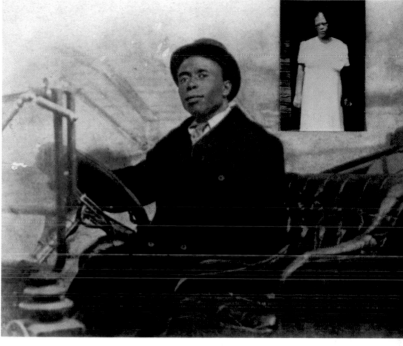

I n his famous speech on race relations during the 2008 presidential campaign, Barack Obama noted at one point that he was "married to a black American who carries within her the blood of slaves and slave owners." Indeed, Michelle's roots lie in the soil of the American South. Left: On Friendfield Plantation in Georgetown, South Carolina, whitewashed shacks, each only 19 feet deep, still stand, lining a dirt road known as Slave Street. Jim Robinson, Michelle's paternal great-great-grandfather, was born circa 1850 and lived here as one of hundreds of slaves until the Civil War ended, in 1865, then stayed on and continued to work the rice fields. The year of his death is unknown, and it is thought that he is buried in an unmarked grave in a slave cemetery on the property. One of his children was Fraser Robinson, above, Michelle's great-grandfather, who was born in 1884. As an adult, he worked various jobs, including one in a lumber mill and another as a shoe repairman. He lost his left arm at some point, and therefore was deemed ineligible for service in World War I. Fraser and his wife, Rose Ella Cohen (above, inset), had at least six children, one of whom was Fraser Jr., born in 1912. Fraser Jr. was among the first generation of Robinsons to graduate from high school. When the local economy collapsed, he headed to Chicago, seeking better prospects. There he married LaVaughn Johnson. Their son, Fraser Robinson III, Michelle's father, was born in 1935. The Chicago Robinsons still have relatives in South Carolina's Low Country.

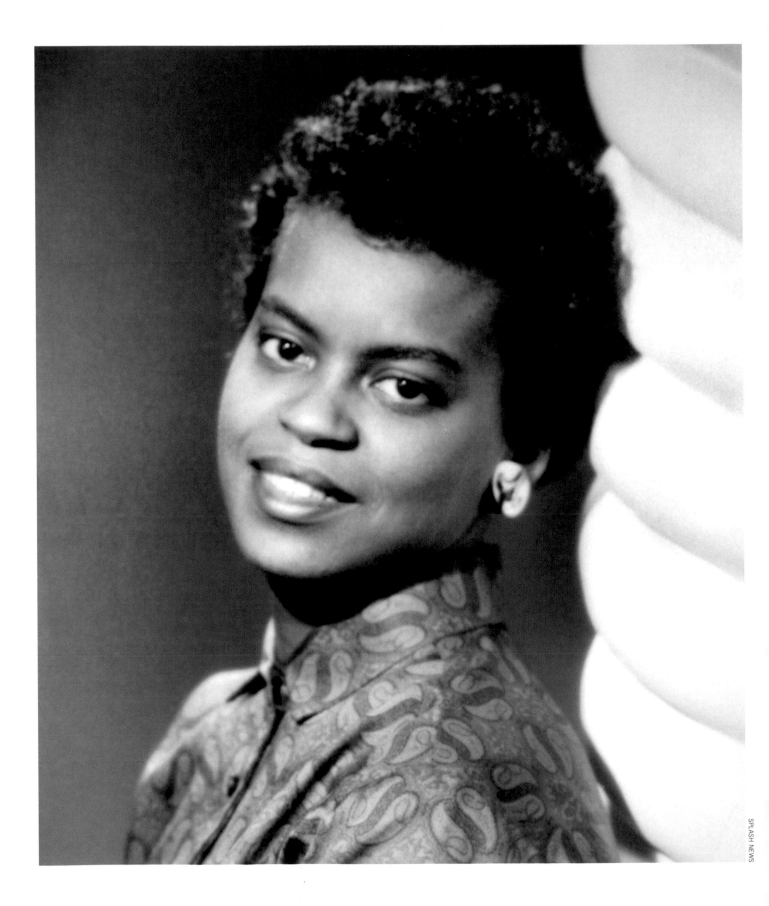

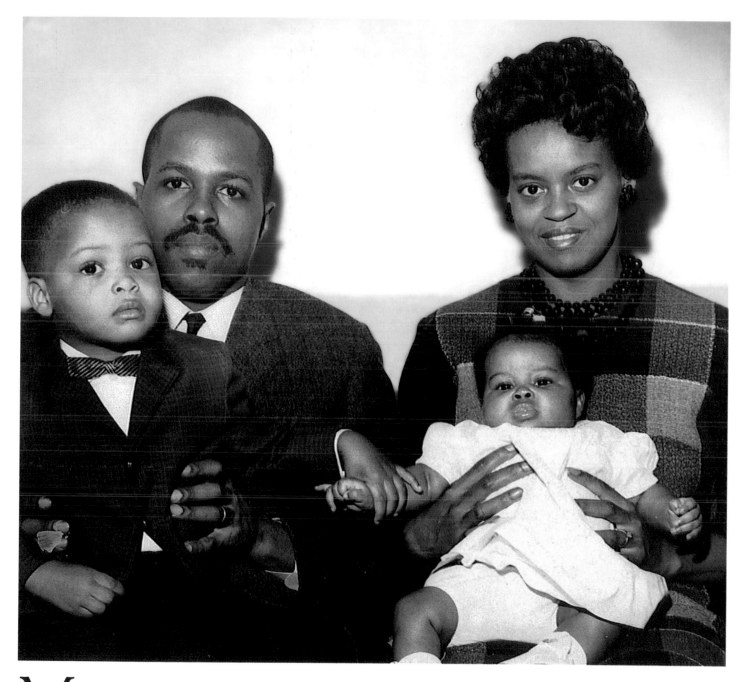

Marian Shields Robinson is seen in a portrait, opposite, and above, with her husband, Fraser Robinson III, and their children, Craig and Michelle, in 1964. Neither Marian nor Fraser went to college, but from the beginning they had it as a goal for their children, and education was emphasized in the household. The children's success at Princeton University was presaged early on when both kids were allowed to skip the second grade at Bryn Mawr Elementary School. Something that Fraser didn't press upon his children but that he certainly handed down was an interest in politics and community service: While working at the municipal water department, he served as the Democratic precinct captain. The neighborhood where the Robinsons lived was blue-collar, largely black and close-knit; Michelle and Craig had a grandmother living only five blocks away, and she and other relatives would drop in regularly. Michelle remembers her upbringing fondly, and said of herself to The New Yorker in 2004: "I was just a typical South Side little black girl." Well, she was anything but typical, as the future would confirm.

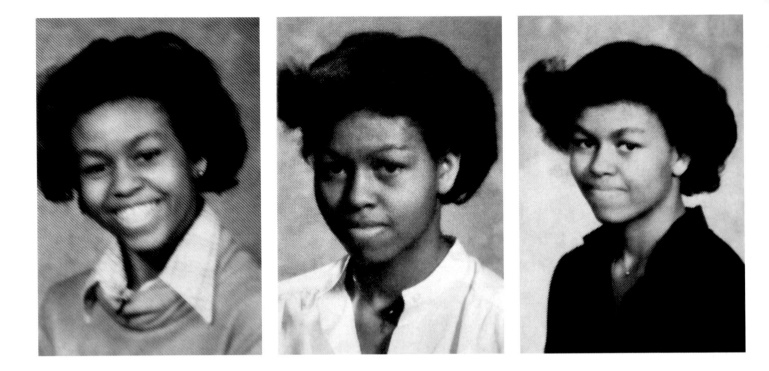

Above, from left, are photographs of Michelle taken in her freshman, sophomore and junior years at the Whitney M. Young Magnet High School. Opposite: While her brother was a basketball star, Michelle took to dance. Michelle's public school education in Chicago, of which she is very proud, formed her in stages. In first grade she was clearly seen as bright; by sixth grade she had been placed in a class for gifted students; and at the magnet school she was on the honor roll all four years. It needs to be noted that her standout performance could not have been easy to achieve. Mayor Richard J. Daley was in office in the 1970s when the Robinson children attended Bryn Mawr Elementary, and, in part because of Daley's segregationist agenda, that was a large, crowded school. Whitney M. Young, named after a civil rights crusader of the 1950s and '60s, was Chicago's first magnet school, and it proved indisputably to be a good idea. But Michelle's commute from the South Shore to the school's West Side location took as long as an hour and a half each way. Years later, Michelle, who has often spoken about how blessed her youth and adolescence were, downplayed any difficulties. "I am the product of your work," she told employees of the U.S. Department of Education when she visited there in early 2009. "I wouldn't be here if it weren't for the public schools that nurtured me and helped me along."

National Honor Society

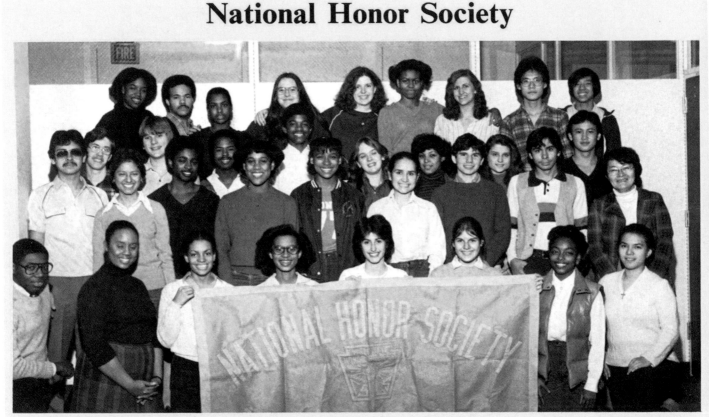

Front: J. Dudley, S. Jackson (Pres.), M. Duster, T. Johnson, B. Casanova, S. Chikow (Sec.), G. Barrett, A. Evangelista. Row 2: A. Velverde, M. Sanchez, K. Smith, R. McNeil, S. Bowen, G. Bustamante, C. Baim, L. Arreola (Treas.), R. Takekawa (Sponsor). Row 3: J. Schwenk, R. Jeka, J. Ratliffe, K. Gist, C. Oehri, N. Ward, R. Florzak, T. Fong. Row 4: J. Hayes, R. Willis, A. DeVold, A. Petrilli, J. Wachowski, M. Robinson, C. McNulty, J. Tam, P. Kovathana, Not pictured: G. Wharton, K. Kerr, (Vice-Pres.), R. Hayden (Vice-Pres.), C. Tatum, O. Sagher.

Without any doubt, Michelle was always one of the "good" kids: She took advantage of all honors and advanced placement classes open to her at Whitney M. Young. And not only was she a member of the school's National Honor Society (above, top row, fourth from right), she also graduated as class salutatorian and was selected for inclusion in Who's Who Among American High School Students, the criteria for which was to "have excelled in academics, extracurricular activities and community service." On the opposite page, we see, at far left, Michelle posing near the high school with her fellow junior class officers. With Michelle Obama's rise to First Lady in 2009, Dr. Joyce Kenner, the school's current principal, was asked by Entertainment Tonight to describe Michelle's achievements in high school. Dr. Kenner said it was "almost unbelievable" for a student from the Chicago public schools to win acceptance at an Ivy League institution at that time. She added that Michelle's life story was a day-to-day inspiration at her alma mater, giving "all children hope that they can do anything they want to do."

BARRY BRECHEISEN/WIREIMAGE

Michelle was a scholar in high school, but she was neither a nerd nor a wallflower. As Dr. Kenner, Whitney M. Young's principal, said in the Entertainment Tonight interview, Michelle was "very, very involved here." This involvement included photogenic endeavors such as singing and dancing, but it entailed as well such private efforts as volunteering to be a notetaker for hearing-impaired students. Of course, the cameras would be out on the night of the senior prom, and the photograph opposite is of Michelle, in a rather daring dress, and her escort, David Upchurch, who lived near the Robinson family's home on Euclid Avenue (above). Amid the hubbub of the Obama election victory in late 2008, Upchurch was tracked down by the press, in Colorado Springs, where he was working as a customer service representative. He said he had "pretty much forgotten" prom night and couldn't even remember if it included a kiss. Upchurch also said that his relationship with Michelle ended when she departed for college. "Michelle knew what she wanted," he told newspaper reporters. "She was off to Princeton University. I didn't take my future seriously, and I couldn't stand in her way. . . . I was a screwup, plain and simple!" He concluded, "I knew Michelle was special. Barack is a very lucky man."

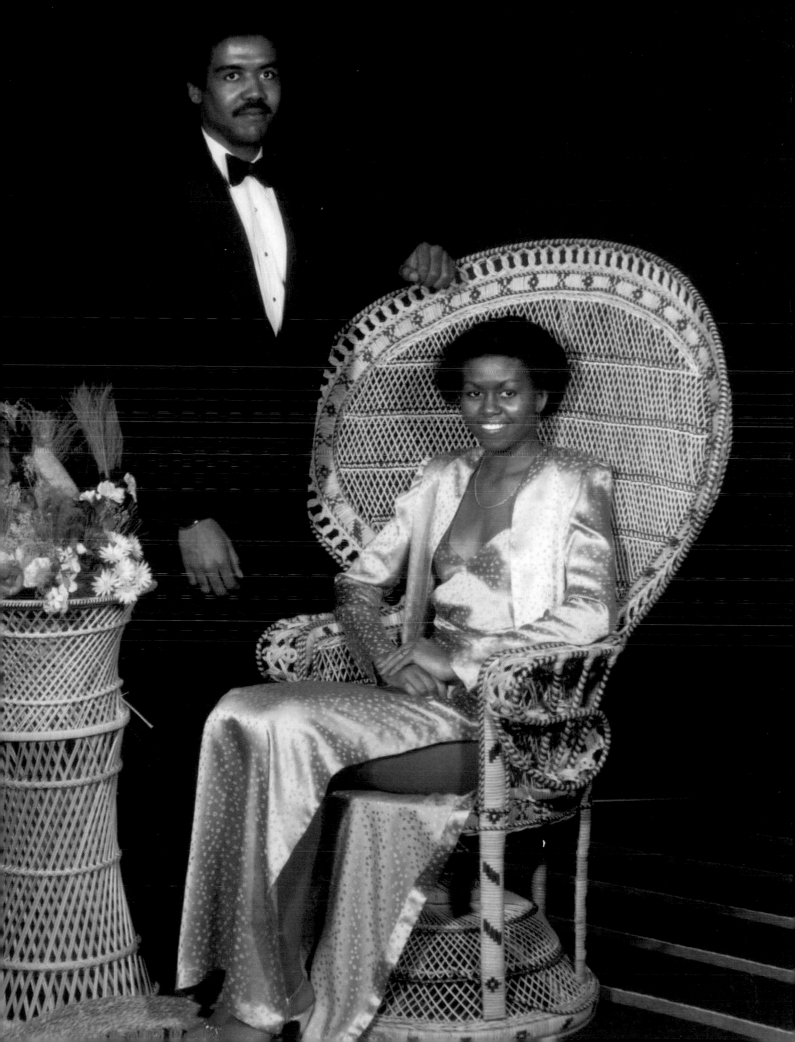

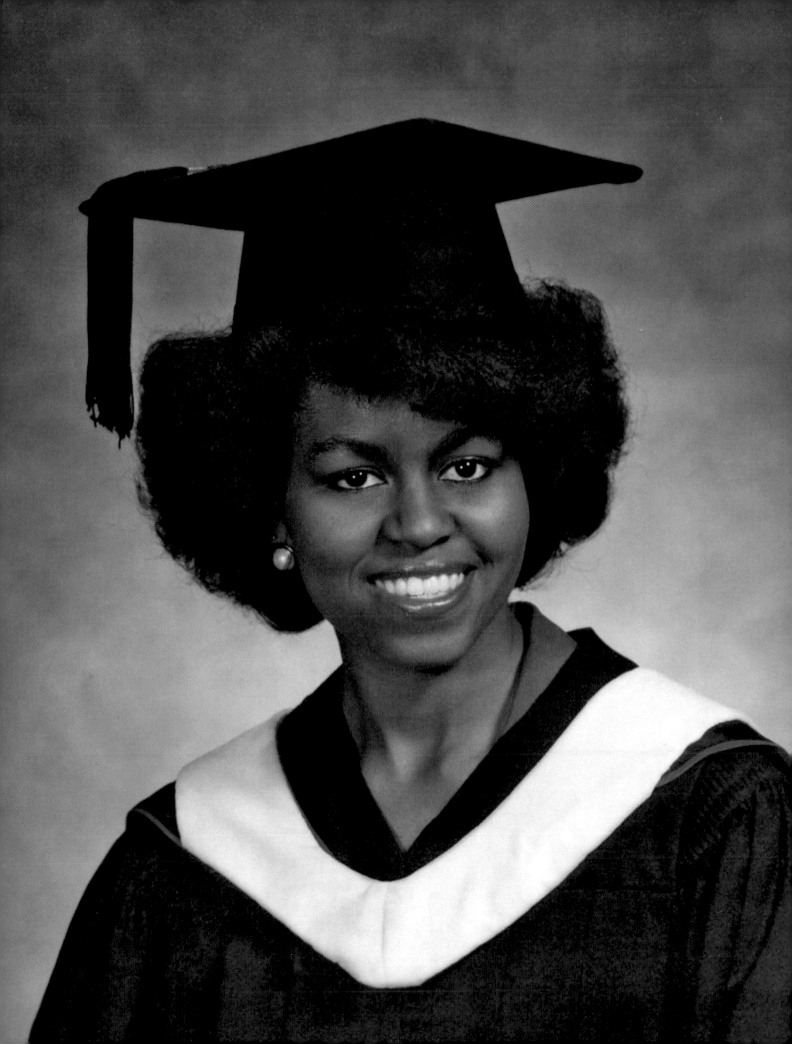

Craig Malcolm Robinson

Thanks God, Friends, and a very special thanks to Marian, Fraser, and Little Miche.

Without your help and guidance all of this would have only been a dream.

Y'all are real sureshots!

Thank-You

7436 S. Euclid Avenue
Chicago, IL 60649

April 21, 1962

Sociology

Independent, Third World
Center, Varsity Basketball,
Organization of Black Unity,
Big Brother Program, East
Harlem Exchange Program

7436 South Euclid Avenue
Chicago, IL 60649

January 17, 1964

Sociology

Stevenson Hall; Third World
Center — Work Study; Third
World Center — Governance
Board Member; Organization of
Black Unity; Third World
Center After School Program —
Coordinator

Michelle LaVaughn Robinson

There is nothing in this world more valuable than friendships. Without them you have nothing.

Thank-you Mom, Dad and Craig. You all are the most important things in my life.

As Dr. Kenner indicated, the idea of such as the Robinson kids both coming out of Chicago's inner-city schools and heading off to the hallowed halls of Princeton University when they did was way beyond unlikely. It was unheard of, almost unimaginable. But they both went, they both achieved further success and they both graduated. Craig was the first to go but was concerned, after being admitted, that he would pile up student loans at an institution that couldn't, under Ivy League rules, offer athletic scholarships, whereas he could easily get a free ride on his basketball skills elsewhere—indeed, he already had offers from Indiana's Purdue University and the University of Washington. But his father insisted that he not worry about money: If you have earned a Princeton education, then the bills will be paid. Michelle, too, proceeded upon her path in higher education with ever-increasing debts, which she would subsequently wind down after securing, as her brother also would, a well-paying job back in Chicago. The pictures and yearbook entries above speak for themselves. The photograph opposite is Michelle's Princeton University graduation picture.

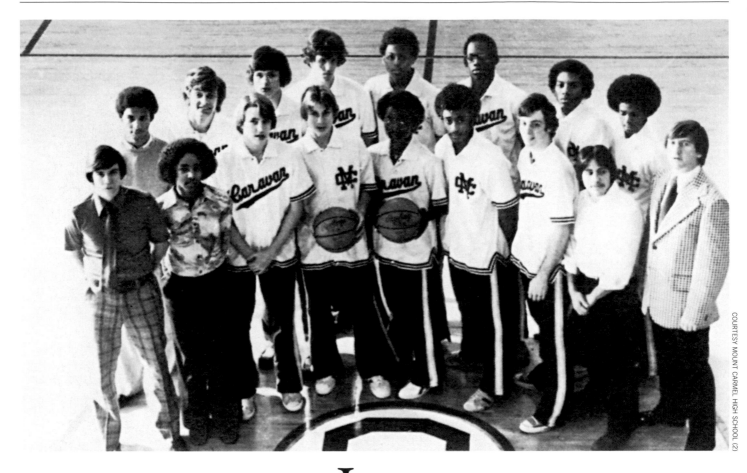

In the considerable discussion that has ensued since the Obamas first entered the national consciousness, the importance of the preachers, the political mentors, the sidekicks and aides and hangers-on is a topic that has been discussed ad nauseam. But it can still be argued at this late date that too little has been said about Craig Robinson, since the influence that a strong and confident older sibling carries is always substantial. When the younger sibling follows in an elder's path, as Michelle did, it is clear that he or she has been inspired by example. Born April 21, 1962, Craig became well-known at Mount Carmel High School as a smart kid and even better known as a hoops star (above, back row, fifth from right). At Princeton (right, as a six-foot-six forward), he was twice named Ivy League Player of the Year and remains the fourth-highest scorer in the school's history. After graduating, he played two years of pro basketball in England, and in a sideline assignment, scrimmaged with Chicago Bulls immortal Michael Jordan when the superstar was preparing his comeback to the NBA. Robinson then shifted gears, earning an M.B.A. at the University of Chicago Booth School of Business and making a ton of money throughout the 1990s in finance and investment banking. But as would happen with his sister in her initial professional foray, Craig determined he wasn't finding personal satisfaction. He returned to basketball, and in his first head-coaching job turned around a lackluster program at Rhode Island's Brown University, winning Ivy League Coach of the Year honors in his second season. He moved on to a bigger stage at Oregon State, where he similarly righted a leaky ship in the 2008–2009 campaign. And speaking of campaigns: He was very active in his brother-in-law's push for the presidency and introduced his sister to the crowd at the Democratic National Convention in 2008.

Princeton

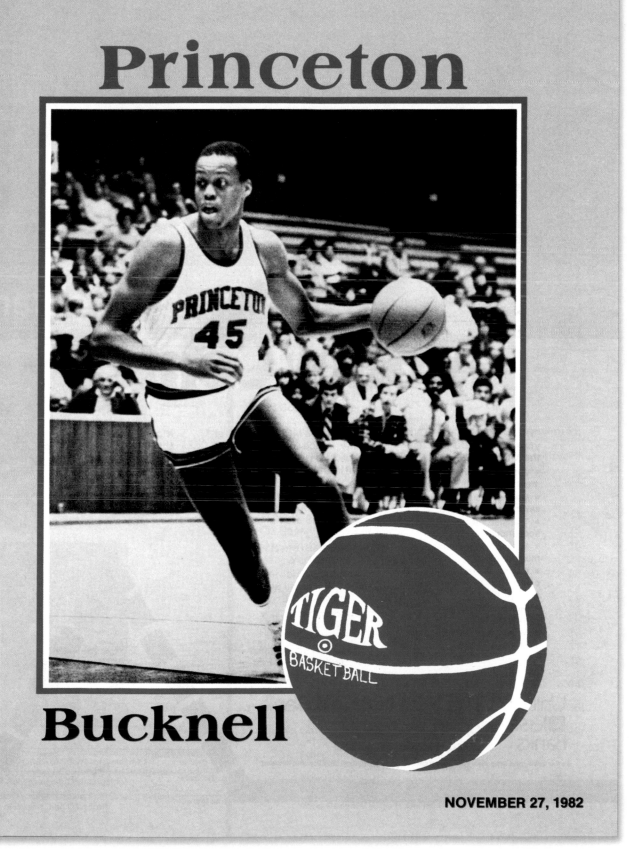

Bucknell

NOVEMBER 27, 1982

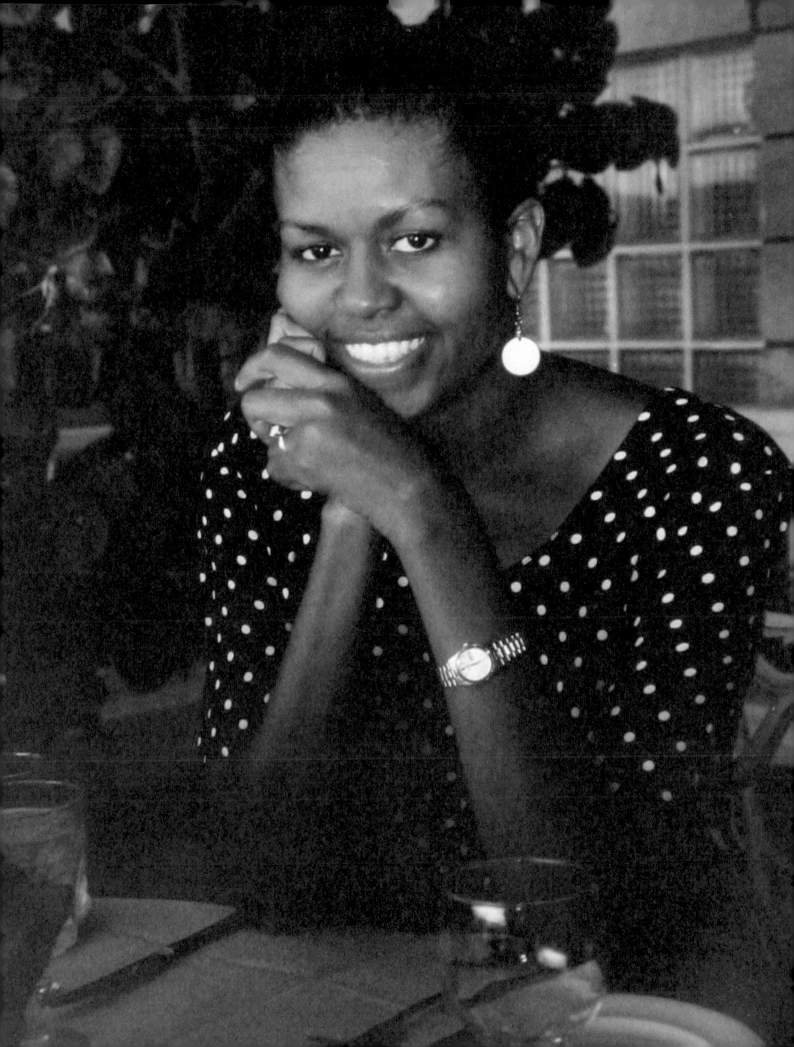

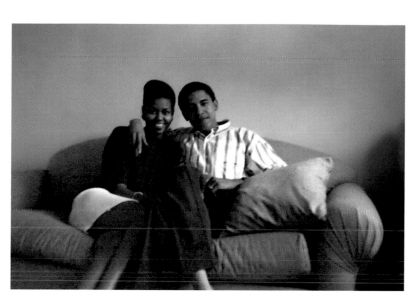

Opposite: Michelle, shortly after graduating from Harvard Law School. Her career and concerns in college and grad school have been well documented (and discussed previously in these pages). Michelle's social life during this time has been only lightly touched upon, but it is known that she had a boyfriend while at Princeton and another at Harvard. Both gentlemen, said to be impressive (the latter reportedly the son of a famous singer), have discreetly and gallantly refused to discuss the past. But the key point is: Nobody followed Michelle back to Chicago, and there she was free to fall in love with Barack Obama, seen here with her in two pictures taken during the couple's courtship in the late 1980s and early '90s. The photograph below and the one on the pages immediately following are of particular interest: They were taken in 1992 when Michelle and Barack, now engaged, traveled to Africa to visit the land where Barack's father, who had died 10 years earlier, was raised.

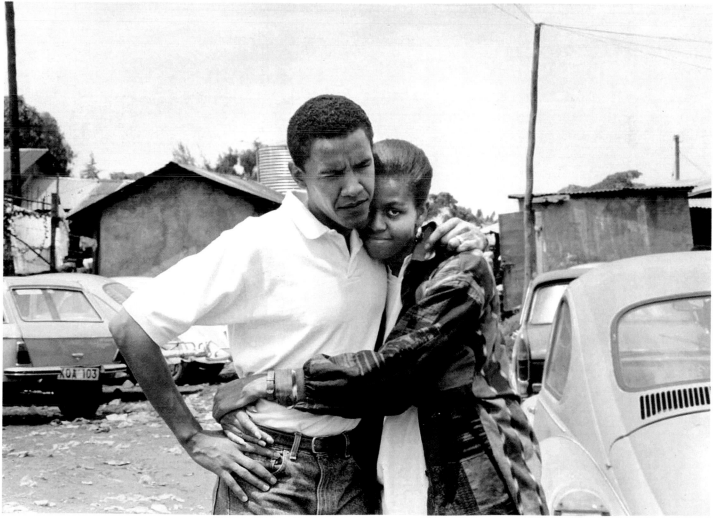

Michelle is in Alego, a small, sleepy village on the shores of Lake Victoria in Kenya's Nyanza Province. Here and in the precincts surrounding live several members of Barack's family. He is known to them as "wuod Sarah," or "the son of Sarah," though this is not a technically factual appellation. Sarah Ogwel Onyango Obama—"Granny," as Barack calls her—is not a blood relation but rather a step-grandmother. Nevertheless, as Barack's grandfather's third wife, it was she who was principally responsible for the upbringing of Barack Obama Sr., Barack's father. She, like all of the close and remote relatives in Kenya, is proud of Barack as he succeeds in the United States, but Granny will grow weary of all the attention, lamenting to a journalist as early as August 2004, well before the presidency is in prospect, "I can't live here in peace. I have been talking to visitors for several hours a day. I have been interviewed a thousand times, and I am tired." During Barack and Michelle's earlier visit, she, of course, was the perfect hostess. They stay nearly a week in a small room in Granny's old brick house. They eat native foods; family members teach Michelle how to use traditional pots called "agulu" and where to fetch water from a nearby stream. When the Obamas return to Africa several years later as rising stars on the American political scene, there will be fanfare bordering on fever. But this time all is quiet, as Michelle gets to know her future in-laws.

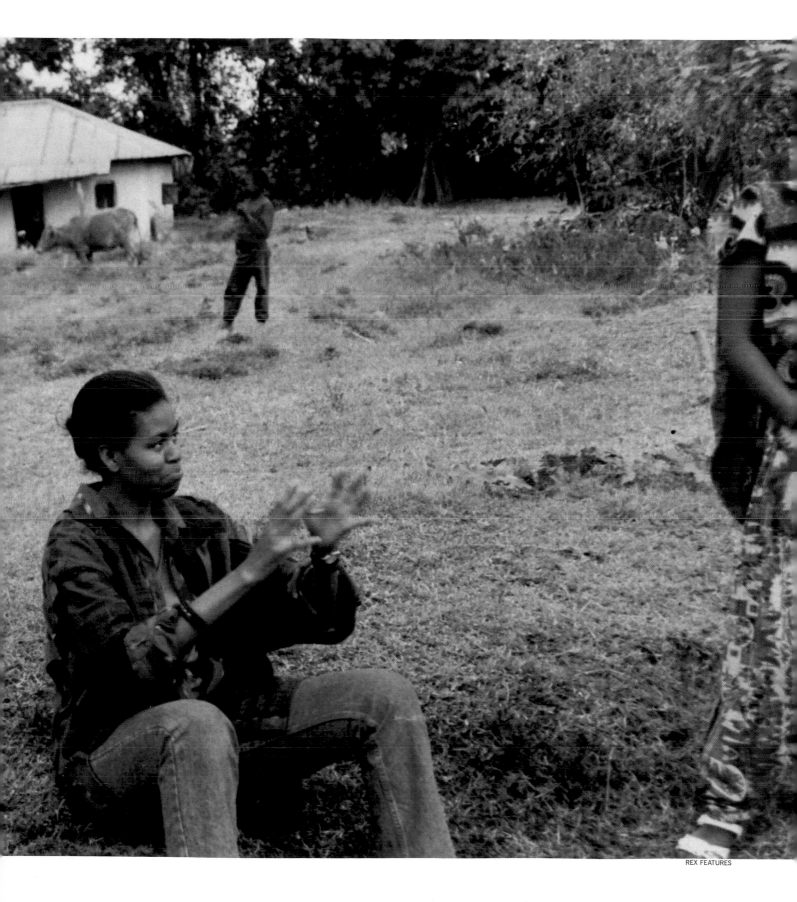

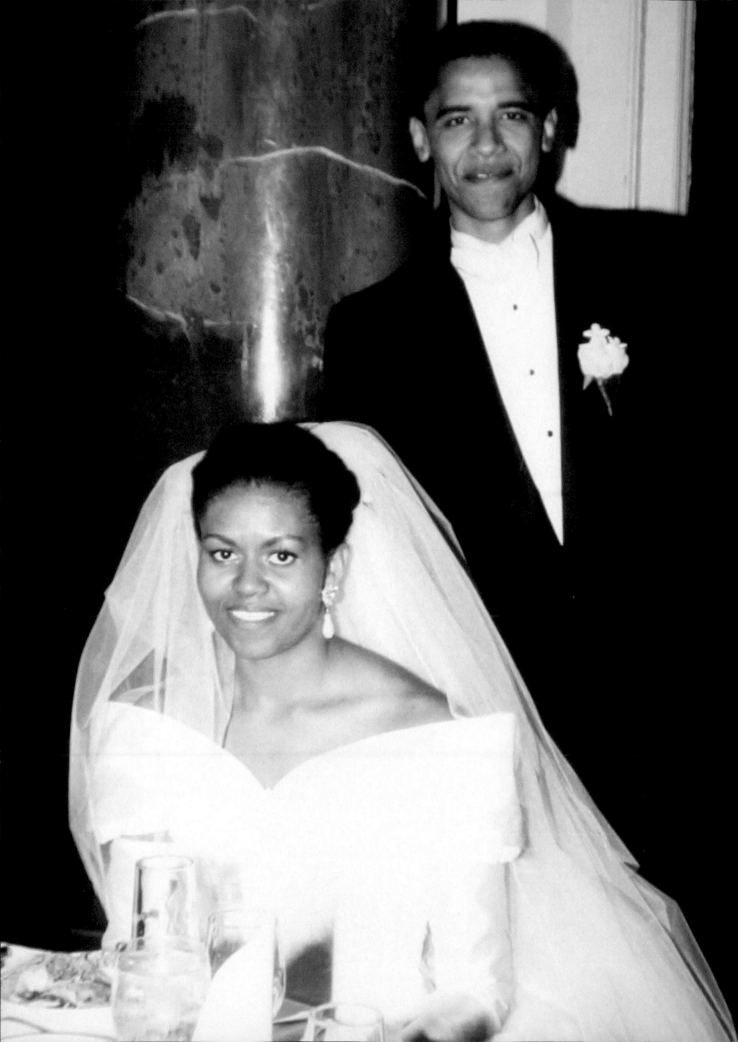

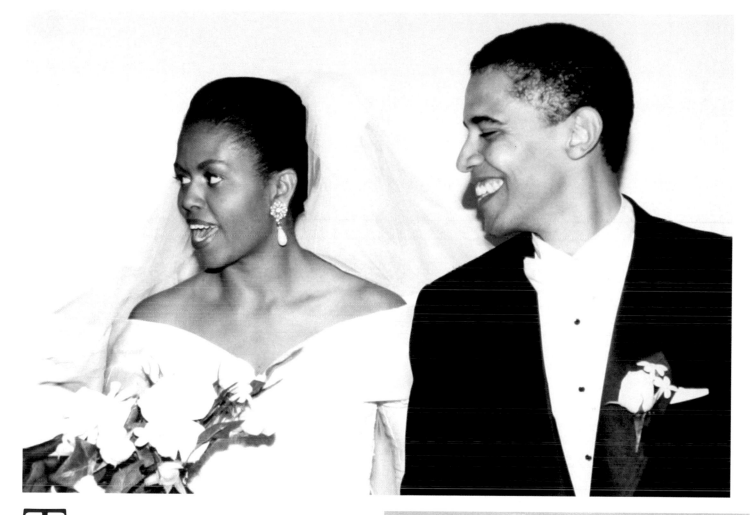

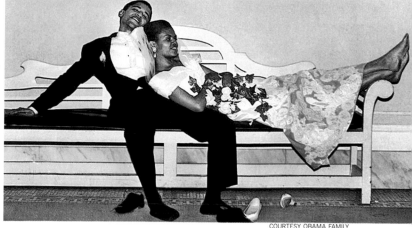

COURTESY OBAMA FAMILY

The blessed day! Michelle and Barack are wed on October 3, 1992, in Chicago's Trinity United Church of Christ, where both of them worship regularly. Officiating, as mentioned earlier, is the church's pastor, Reverend Jeremiah A. Wright Jr. This man had already had a huge influence, on Barack's life in particular. It is safe to say that when Barack arrived in Chicago in 1991, he was not deeply religious—he had inherited his mother's skepticism. Early one Sunday, however, he attended services at Trinity United and was moved to tears by Reverend Wright's sermon, the title of which was "The Audacity of Hope." Barack would find faith and be baptized at Wright's church (as would his two daughters). And so it was natural for Barack and Michelle to turn to the pastor as they planned their nuptials. Subsequently, during the presidential campaign, their association with the pastor would become an enormous problem when video footage surfaced of Reverend Wright making inflammatory statements, among them condemnations of the U.S. for its treatment of blacks, charges that Washington's foreign policy had brought on the attacks of September 11, 2001, and suggestions that the government had invented HIV in order to spread it among minorities. Obama would criticize his pastor but did not immediately throw him over. He was finally forced to do so, however, when Reverend Wright refused to repudiate his remarks and, in fact, added to them.

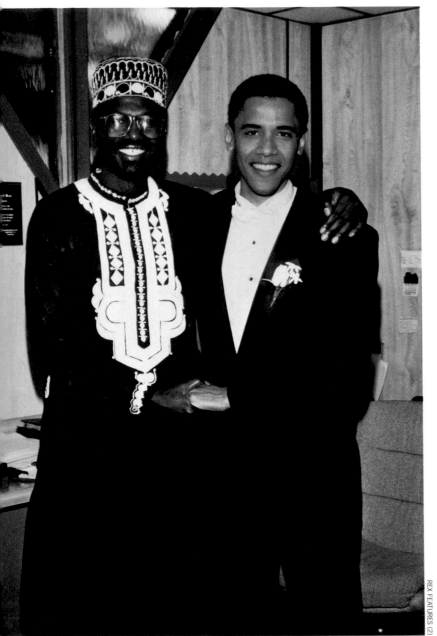

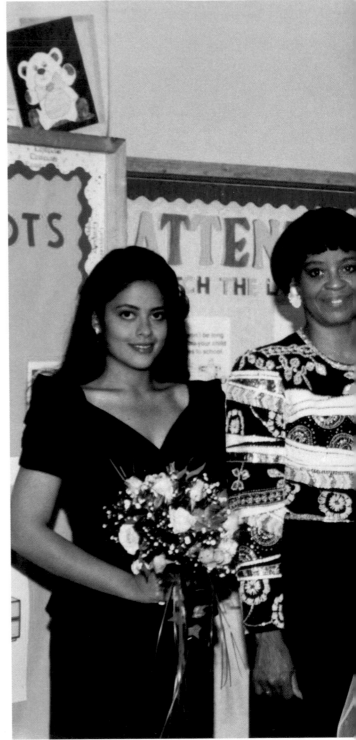

REX FEATURES (2)

SAUL LOEB/GETTY

Left, top: Barack poses with his half brother Malik Abongo Obama, who had traveled from Alego, Kenya, to Chicago to serve as best man. Left, bottom: The South Shore Cultural Center, where the wedding reception was held. Above: The bride is attended by, from left, Maya Soetoro, Barack's half sister from his mother's second marriage, to Lolo Soetoro; Marian Robinson,

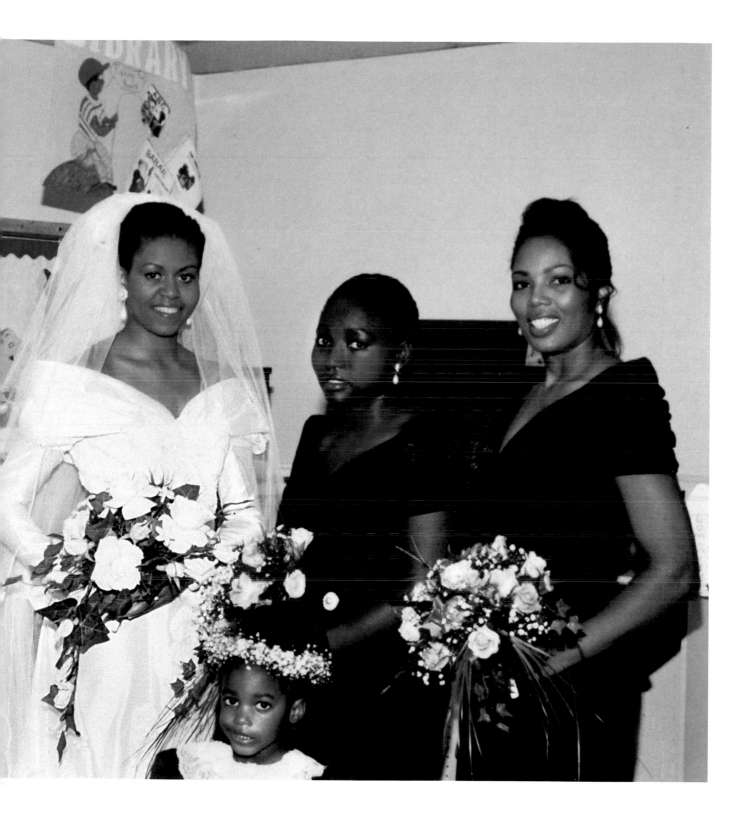

Michelle's mother; Auma Obama, another half sister of Barack who came over for the event; and Janice Robinson, Craig's wife (they have since divorced). Barack's mother, Ann Dunham, had made the trip from Hawaii to celebrate the wedding; she would die only three years later of ovarian cancer. These photographs merely hint at the tangle that is Barack Obama's roots (his father was married three times and sired eight children by four different women). Michelle made light of this later in an article in The New Yorker, alluding to Ann Dunham's native state, Kansas, and saying: "[W]e're both Midwesterners. Underneath it all, he's very Kansas, because of his grandparents and his mom. Our families get along great."

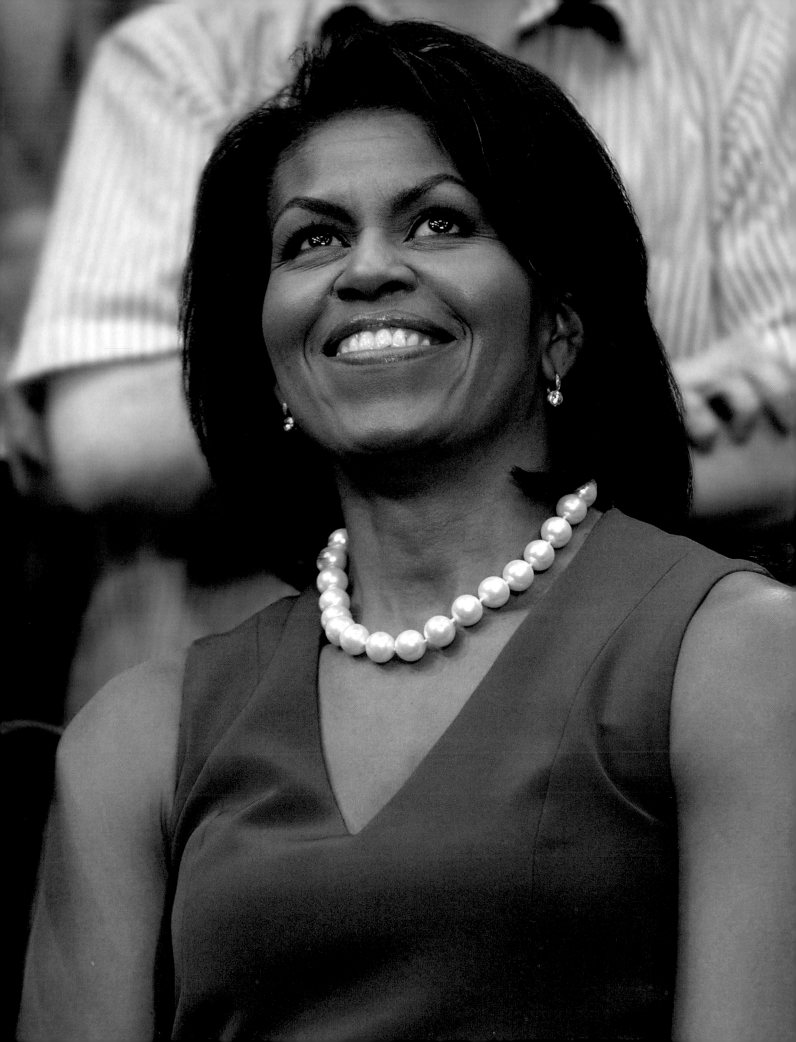

MICHELLE OBAMA

IT IS CERTAINLY INTERESTING, IN RETROSPECT, to note how Michelle's redirection of her own career had a salutary effect on her husband's rise in Chicago and Illinois politics. After he had graduated from Harvard Law in 1991, Barack had run a drive in Chicago that registered 150,000 black voters, then had joined the small but politically connected civil rights law firm of Davis, Miner, Barnhill & Galland. And now his wife was working for the city in a position that put her and Barack squarely in the center of influential local circles, where they would build some dear friendships and long-standing professional relationships. Almost as soon as Michelle arrived for work at City Hall, deputy chief of staff Valerie Jarrett was promoted to the directorship of the city Department of Planning and Development, and Jarrett brought her new protégée along as the economic development coordinator. That's a real-world job dealing with businesses and individuals as they seek to navigate the municipal maze, and the deftness Michelle displayed in making problems go away—Jarrett said that calling Michelle was like dialing 9-1-1—made her many friends.

The newlywed Obamas moved into a condo, laying roots in the South Side liberal stronghold of Hyde Park. Michelle still wanted to do more—to contribute more—and left city government after a year and a half to become the founding executive director of the Chicago chapter of Public Allies, an organization that helps groom young people as future public service leaders. Her career path now featured two straight pay cuts as she went from the blue-chip law firm to

On June 3, 2008, in St. Paul, Michelle joyfully shares in the victory as Barack clinches the Democratic nomination for President of the United States.

the city to the nonprofit, but the opportunity to influence change proved irresistible.

Beyond their hectic work lives, Michelle and Barack were adjusting to life together under the same roof. Michelle was a morning person; Barack stayed up late. He writes in *The Audacity of Hope* that he "could be a bit grumpy (mean, Michelle would say)" after waking. His late-night work on his first book, *Dreams from My Father*, left Michelle feeling lonely. Barack would later write that he "invariably left the butter out after breakfast and forgot to twist the little tie around the bread bag." Michelle, for her part, "could rack up parking tickets like nobody's business." These minor strains were as nothing compared with the ones that would come once the Obamas stepped aboard the political roller coaster.

Which happened sooner rather than later.

Barack had previously expressed an interest in politics; Michelle could always recall the first time he'd brought it up: "I said, 'I married you because you're cute and you're smart, but this is the dumbest thing you could have ever asked me to do.'" But when her husband, now 34 years old, saw that there was an opening to run for the state senate in 1995, she gave him her blessing. She believed that she and

Barack, with their extensive schooling and general good fortune, had an obligation to give back to the community—and if politics was to be the way, then politics was to be the way.

Barack won election to the Illinois Senate in 1996 and began splitting his weeks between the statehouse in Springfield and his home in Chicago. Michelle, in the meantime, switched jobs yet again. She left Public Allies for the University of Chicago, where she became an associate dean, helping to organize student volunteer work.

What to add to the mix now?

Well, why not kids?

ON JULY FOURTH, 1998, Malia Ann Obama was born, her middle name honoring Barack's mother, who had died in 1995 of ovarian cancer, at only 52 years of age. The timing of Malia's arrival was optimal, as the state senate was in summer recess. "For three magical months," Barack wrote in *The Audacity of Hope,* "the two of us fussed and fretted over our new baby, checking the crib to make sure she was breathing, coaxing smiles from her, singing her songs, and taking so many pictures that we started to wonder if we were damaging her eyes."

In the fall, the idyll ended, and it was back to reality as the senate reconvened and Michelle returned to work. Barack's political ambition got the better of him in 2000 when he challenged an incumbent Democrat for a seat in the U.S. House of Representatives; he was drubbed in the primary by a two-to-one margin. Michelle had already been unhappy with his decision to run—which had meant Barack would be absent much of the time, either doing his job or trying to win the next one—and the loss, after a campaign that had all but emptied the family's bank account, did nothing to make things cheerier at home. "My failure to clean up the kitchen suddenly became less endearing," he wrote. "Leaning down to kiss Michelle good-bye in the morning, all I would get was a peck on the cheek." Barack told biographer David Mendell that by the time the family went to visit his grandmother in Hawaii for Christmas, Michelle was barely speaking to him. Although they were of course delighted on June 10, 2001, by the birth of their second daughter, Natasha (who would be called Sasha), a family crucible brought new and greater tensions shortly thereafter. At only three months old, Sasha was hospitalized

with a severe case of meningitis. The Obamas suffered tearfully as their helpless infant underwent a spinal tap and other procedures, which, to their infinite relief, proved successful. Sasha got well, but soon enough Barack had to return to the work he had been elected to perform. "You only think about yourself," Michelle would tell him. "I never thought I'd have to raise a family alone."

Such words hit home. Writing later, Barack conceded that the roles of husband and father, which his own dad had handled horribly, caused him great doubts, and he often contended with the thought that the professional choices he had made were indeed purely selfish: "I may tell myself that in some larger sense I am in politics for Malia and Sasha, that the work I do will make the world a better place for them. But such rationalizations seem feeble and painfully abstract when I'm missing one of the girls' school potlucks because of a vote, or calling Michelle to tell her that session's been extended and we need to postpone our vacation."

He wrote that he ruminated on the warm reverence with which Michelle often talked about her own father, Fraser, a reverence that was "earned not through fame or spectacular deeds but through small, daily, ordinary acts—a love he earned by being there. And I ask myself whether my daughters will be able to speak of me in that same way."

Today, he unfailingly credits Michelle with keeping the family together through those early years in politics. And he recognizes that, although his wife is no less ambitious than he is, having kids wound up meaning that she was changing her plans while he was allowed to continue full bore with his. It was Michelle who fed, clothed and bathed the girls and coordinated their day-to-day schedules with what Barack calls "a general's efficiency." She gave Malia and Sasha a sense of stability and routine that, at least until they took up residence at the White House, passed for something close to a "normal" childhood.

In 2002, Michelle made yet another job switch. She had been approached by the University of Chicago Hospitals; hamstrung without a babysitter, she went to the interview with a slumbering Sasha in tow. She was offered a position as executive director for community affairs, charged with soothing tensions between the medical center and its South Side neighbors, and boosting minority contracting. Michelle was successful in steering projects to minority- and women-owned businesses and overseeing exponential increases in

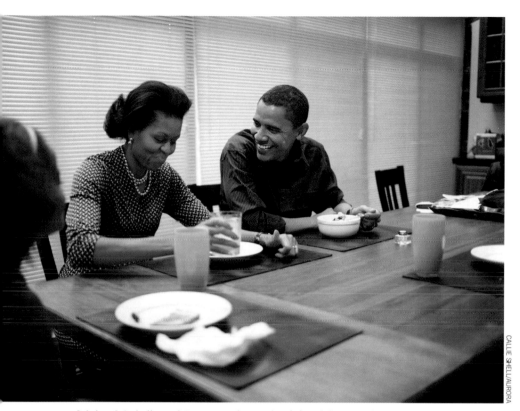

Malia, Michelle and Senator Obama finish breakfast in Chicago in 2006. By this point, he had been trained to wash the dishes.

volunteerism among community members helping in the medical center and employees going out into the community. She found the work fulfilling, though it did little to make her domestic situation any easier.

Considering all the Sturm und Drang in the Obama household at the time, it is nothing short of entertaining to imagine the trepidation with which Barack approached Michelle in 2002 to say something along the lines of, "Um, honey, I'd like to run for the U.S. Senate. Can I? Please?" He sold it to her as an "up-or-out strategy"—if he didn't win he was prepared to forsake politics altogether. Eventually she agreed to the race. When she did, according to David Mendell, she told her husband with a smile, "And maybe you'll lose."

He did not.

"IF HER HUSBAND IS ONE FOURTH AS GOOD AS SHE IS, he'll be excellent."

So said a woman who had just heard Michelle speak to a crowd of 800 Illinois voters during the 2004 Senate campaign. After blessing her husband's effort, Michelle offered her own by getting actively involved in the campaign, finding her political legs. Simply because she was a woman and a working mother, she expanded the campaign's reach. As she would later do on the presidential campaign trail, she helped make Barack easier to relate to.

She also, in this period, made some personal decisions that allowed her to get a better handle on the home front, on herself and on her aspirations. She was watching her husband work an 18-month stretch before the Senate primary in which he would have precisely seven days off, and she realized she had to change strategies—and end her feelings of frustration. As she told the *Chicago Tribune*, "I cannot be crazy, because then I'm a crazy mother and I'm an angry wife." Her question to herself, as she later expressed it to *People* magazine: "How do I structure my world so that it works for me and I'm not trying to get him to be what I think he should be?" She hired a housekeeper to handle the chores that she didn't "fully enjoy, like cleaning, laundry and cooking." This allowed the precious time she was able to carve out with Malia and Sasha to be quality indeed. She came to realize that "it matters less to me that Barack's the one [helping with] babysitting and giving me the time for myself; it's that I'm getting time."

So things were improving at home, and they were going insanely well in the campaign. The serendipitous circumstances that Barack Obama enjoyed in his underdog run for the Senate—one front-runner after another getting caught up in scandal and either bottoming out in the polls or having to quit the race entirely—is the stuff of Illinois political legend. In early 2004, he surged from next to nowhere to beat six opponents in the Democratic primary, then watched, probably with an attitude somewhere between

51

bemused and mirthful, as his Republican opponent in the general election had to withdraw, leaving Obama a clear favorite against an out-of-state replacement, the archconservative Alan Keyes. National newspapers noticed the circuslike election and ran stories that helpfully included the correct pronunciation of this new name— "bah-ROCK oh-BAH-ma"—on the political scene. Most Americans were still unfamiliar with the name when, during the campaign, this young man who was clearly headed for the Senate was tapped to deliver the keynote address at the upcoming Democratic National Convention.

He knew the speech would be important to his political stock; no one ever could have anticipated just how important. He asked Michelle to be among his stand-in audience as he prepared the address; her assessment, he told reporters, "was that I wasn't going to embarrass the Obama family." Michelle not only assisted with the words but also helped her husband's staff punch up his outfit. She approved of a blue necktie being worn by communications director Robert Gibbs, and that became Obama's cravat on the big night in Boston. (Gibbs, it is worth noting, has gone on to become the presidential press secretary.) Finally, backstage, Michelle gave Barack a hug and a reassuring look, then playfully admonished: "Just don't screw it up, buddy!"

In a thrilling performance, Barack laid out a vision of a hopeful America where cooperation and fairness were exalted values, and where opportunity was not only possible but an inalienable right. He became a rock star overnight, which in the days and weeks to come, as the Obamas worked the crowd at the convention and then returned to the campaign in Illinois, amused his wife. "I was like, 'You want to talk to him?'" she said at the time. "'You're in line for him? Yeah, he's terrific, but come on.'"

Just before Barack was chosen by the electorate to serve as the junior senator from Illinois, his very candid wife conceded to the *Chicago Sun-Times* that life would "be

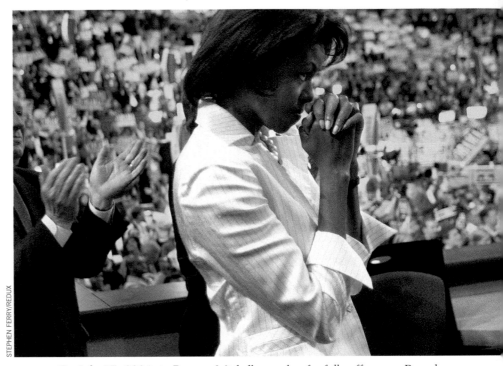

On July 27, 2004, in Boston, Michelle watches fretfully offstage as Barack gives his triumphant, career-changing speech to the Democratic National Convention.

easier if my incredibly talented husband went off and made lots of money." She added that politics, sometimes, felt like "a waste of time."

With the race won, the Obama family went to Washington in January 2005 for Dad's swearing-in. As Michelle watched her husband, who was being celebrated in a fashion unlike that of any other freshman senator, walk the Capitol corridors attended by a gaggle of media, she said, "Maybe one day he will do something to warrant all this attention."

"MICHELLE OBAMA IS JUST LIKE ME. AND YOU. And your stylish-but-harried working-mom neighbor who, right at this very moment, is struggling to get the groceries out of the car as her cell phone rings and her toddler demands a snack."

So ran a story in the *Chicago Sun-Times* in 2004, which continued: "But there are a few ways in which Michelle Obama is not exactly like us. Mostly, these involve the frequency with which people describe her as a 'future First Lady.'"

Indeed. Although Senator Hillary Clinton of New York was considered a favorite to be the Democratic Party's 2008

presidential nominee, there had been speculation ever since Barack Obama's dramatic bow before a national audience at the 2004 convention that he might run. Whether he put such thoughts completely from his mind in his earliest days in the Senate, only he knows, but certainly there was work to be done before another campaign was considered.

While her husband's job was now in Washington, Michelle opted to remain in Chicago and raise the children there; the family's time together was limited to extended weekends. Toward the end of 2005, though, when Barack's political commitments started to encroach on even these sacrosanct reunions, Michelle made her discontent known during an interview with the *Chicago Tribune*. "The hope is that that is going to change and we're going to go back to our normal schedule of keeping Sundays pretty sacred," she said, turning from the reporter to look pointedly at Barack's communications director, one of the senator's principal schedulers.

In 2005, Michelle was promoted at the University of Chicago Hospitals to the post of vice president for community and external affairs. Her salary more than doubled to $316,962, and the timing of this elevation—*Oh, the new senator's wife gets a hefty raise!*—was questioned in some corners. The medical center insisted that there had been discussion of promoting Michelle even earlier but that she herself had preferred to hold off until her husband's Senate campaign was finished. Michelle chafed at any insinuations of patronage and at the notion that she might be riding her husband's success. "I'm a vice president at an academic medical center," she told the *Chicago Tribune* in 2007. "Barack and I have built a joint life together that consists of having two strong individual people who have built careers. . . . I understand why people want to make sure that somehow I'm not using my husband's influence to build my career. And I haven't." Michelle's considerable effort to maintain and advance her own career was all about security, about protecting her family. As she confided to biographer David Mendell, "I need to be in a position for my kids, where, if they lose their father, they don't lose everything."

"Everything" was growing to be an upper-class life, something Michelle had never known. In 2005, after the Obamas received some windfall payments from Dad's side career as a memoirist, Michelle and the girls moved into a $1.65 million house on the South Side, not far geographically from the apartment where Michelle had been a little girl but, in another sense, a world away. What could possibly upset such a comfortable existence in her beloved hometown? If Michelle suspected the answer to that question earlier than 2006, she knew it for certain that year when she became involved in earnest, top-level discussions over whether Barack should make a bid for the presidency in 2008.

"I thought, Uhhhh—you're kidding! . . . Can we get a break, please?" Michelle later told *Vanity Fair*. She required hard answers from her husband's aides and strategists. She needed to know that Barack was a bona fide contender, that the campaign would be expertly run and that this was going to be it—the one shot, not the first of several. "To me, it's now or never," she told *Vanity Fair*. "We're not going to keep running and running and running, because at some point you do get the life beaten out of you. . . . We need to be in there now, while we're still fresh and open and fearless and bold. You lose some of that over time. . . .

"There's an inconvenience factor there," she continued, "and if we're going to uproot our lives, then let's hopefully make a real big dent in what it means to be President of the United States."

Of her husband, she made a special demand: that he give up smoking. He promised he would. Michelle believed him, and she climbed aboard.

She was, at the outset of the campaign, less concerned with her image and what role she might play in swaying the electorate than she was in establishing a new routine for the family. "I know that my caricature out there is sort of the badass wife who is sort of keeping it real, which is fine," she told biographer Mendell. "What I am not willing to do is hand my kids over to my mom and say, 'We'll see you in two years.' That's not going to happen. . . . There has to be a balance and there will be a balance." She first cut back her hours at work; she would eventually take unpaid leave for all of 2008 and resign in January 2009. And then, as she herself became more integral to the campaign, she would manipulate her schedule with an eye to Malia and Sasha, spending long days on the road and in the air in order to regularly make it back to Chicago to tuck them in.

Once she had found some rough (if frenetic) semblance of "balance," she proved that she could be of critical importance as a campaigner. Venturing out on solo engagements and sometimes with her daughters, Michelle drew hundreds

and then thousands to rallies and left many listeners with a sense of her personal authenticity. She wasn't as careful as most other politicians' spouses, and this had its appeal. "She's not like a plastic talking head the way that some of them can be," one woman waiting to hear Michelle speak in Rhode Island told the Associated Press. "She's an actual person, a real person." In Iowa, she earned the nickname "the Closer" inside the Obama camp for her ability to convince undecided voters to sign cards pledging support.

Women, in particular, responded warmly to her, and this would be a great asset to a campaign that had to deal with Hillary Clinton in the primary season and Sarah Palin in the general election. Michelle's principal message to her female audience was that she understood them—their trials and tribulations. Talking to a group of female supporters in April 2007, Michelle trotted out what would become a familiar lament, one that many in her audience could relate to: the difficulty of juggling her kids' lives, the campaign, her own professional endeavors—and then also finding time to get her hair done and to squeeze in some exercise: "I wake up every morning wondering how on the earth I am going to pull off that next minor miracle to get through the day. I know that everybody in this room is going through this. That is the dilemma women face today. Every woman that I know . . . is struggling to keep her head above water." She did mention that her lot differed from theirs by a matter of degrees: "I have the pleasure of doing it all in front of the watchful eyes of our friends in the back," she said, nodding to the press corps. "What's up, people?!

"Other than that," she summed up with a comic's timing, "things haven't changed much." Everyone howled.

As that exchange indicates, she could be witty. She was particularly happy to joke about her husband. Part of her shtick was a routine comparing "Barack Obama the phenomenon" with "the Barack Obama who lives in my house, that guy's not as impressive." Voters learned that the Obama kids found him "snore-y and stinky" in the morning, and that he could take some lessons from their youngest daughter on how to make a bed. A standard punch line was, "You'll have to forgive me if I'm a little stunned at this whole Barack Obama thing." A more loving version of the same sentiment was: "He's a wonderful man, he's a gifted man. But in the end, he's just a man."

Some found her ribbing of Barack's domestic foibles emasculating—"Rather than standing by her man, Michelle prefers to stand behind him, the easier to push him around," wrote a critic for *The American Spectator*—but Michelle, speaking seriously, said that the public was getting a truer picture of the couple's relationship. Addressing the part that a candidate's spouse plays in the campaign, she told *Glamour* magazine, "People have notions of what a wife's role should be in this process, and it's been a traditional one of blind adoration. My model is a little different—I think most real marriages are."

Michelle's frankness—her occasional bluntness—sometimes caused the campaign real headaches. More than once, she made comments that implied Barack's candidacy was a gift of some sort to the country. "I know Barack is something special," she said early on in New Hampshire. "If I didn't, I wouldn't be here." On another occasion she called her husband's run "a once-in-a-lifetime opportunity for us to be graced with a man like him," and often said, "The question is not whether Barack Obama is ready. The question is, are we ready for him?" And then there was this famous declaration, made in two slightly different versions at campaign stops in Wisconsin on February 18, 2008: "For the first time in my adult lifetime, I am really proud of my country, and not just because Barack has done well, but because I think people are hungry for change."

The opposition went to town with that one, saying that Michelle was implicitly—or maybe even explicitly—questioning the patriotism of Americans who weren't backing Barack, and countering further that it was Michelle herself who was anti-American if she couldn't be proud of a country that might not anoint her husband. Michelle responded that she was being misrepresented, but there was no denying that, day in and day out, her view of the nation was at odds with that of many other citizens. Her stump speeches tended to reflect a gloomy view of recent times, revolving around a core opinion that life had gotten progressively harder since the days when she was a little girl—that a single blue-collar salary could no longer support a whole family, that health-care and education had become cost-prohibitive, that a burdensome fear, cynicism and negativity permeated today's society. Some observers who harbored a more boosterish view of the United States simply took exception to her conclusions, while others asked whether gloom and doom was any way to

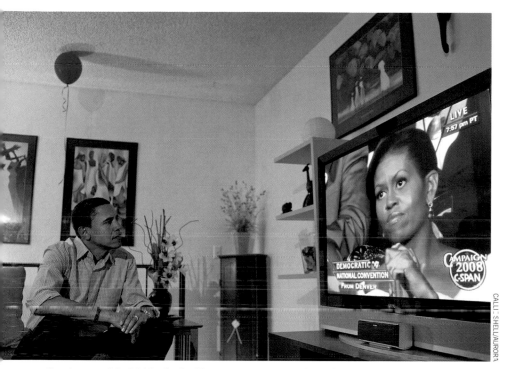

On August 26, 2008, *the highly presumptive presidential nominee watches television in the house of Eran Thompson of Billings, Montana, as his wife watches Hillary Clinton address the Democratic National Convention in Denver.*

could to make the Obamas look scary to Middle America.

If that effort worked in some sectors of society, it didn't work in nearly enough of them, and on November 4, 2008, history was made when Barack Hussein Obama won a large plurality over John McCain and thus was chosen to become the 44th President of the United States. Embracing her husband on the stage that night in Chicago's Grant Park before a quarter of a million cheering supporters and countless more watching on television, Michelle whispered into his ear an entirely apolitical sentiment: "I love you."

In an extraordinary irony, moving away from their hometown and taking up residence in the nation's executive mansion finally afforded Michelle and her family a chance at the sitcom home life that she had once enjoyed and that she wanted for her daughters. The girls see their father more often now. They have playdates; they make their own beds and clean their own rooms; they have alarm clocks to wake themselves in the morning, just as Michelle did growing up. Michelle has instructed the White House staff that the girls will be doing their own chores. "[T]hey don't need their lives to be easy," the self-titled Mom in Chief told *People* magazine in March 2009. "They're kids."

For the first time in his political career, Barack has a job that isn't located "away" in some other city. Therefore, the Obamas can sit down to dinner as a family on most nights—and they do, often with Michelle's mother, Marian Robinson, who lives part-time with them at the White House and part-time in Chicago. They chat and review their days. The girls report on the doings at Sidwell Friends, the private Quaker school that serves the children of many of Washington's power elite. (Chelsea Clinton attended and graduated from Sidwell during her father's administration.) And Dad and Mom tell how things went that day in their respective jobs as . . . well, as leader of the free world and

solve problems. "Mrs. Grievance," critics called her, and Barack's "bitter half."

While it certainly can be argued that Michelle brought such criticisms upon herself, other tempests arose over matters that she had little or nothing to do with. A rumor circulated on the Internet alluding to a videotape that showed her "blasting 'whitey.'" The campaign vigorously denied that anything of the sort existed, and such a tape has never surfaced. And then there was the fist bump that sparked a furor. As any parent of a T-ball- or soccer-playing youngster knows, the bump, or fist pound, or dap, is simply a hipper version of the high-five or handshake. But when Barack and Michelle engaged in one at a rally in Minneapolis, on the night in June 2008 when he had locked up the Democratic nomination, conservatives saw a radical, ominous, threatening act. E.D. Hill, a *Fox News* anchor, speculated that what the Obamas were exchanging might perhaps have been "a terrorist fist jab." The dustup was justly ridiculed by Michelle on the morning show *The View*, where she dapped Barbara Walters and the other hosts, but the larger point remained: Some in the opposition were going to do whatever they

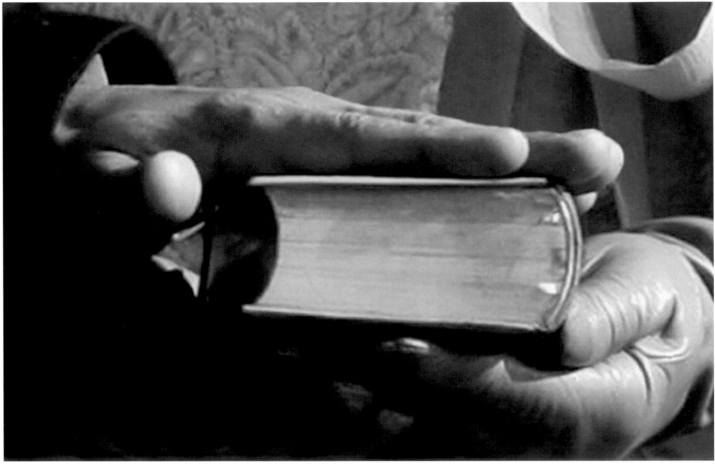

On January 20, 2009, Michelle's gloved hand supports the burgundy velvet–covered Bible upon which Abraham Lincoln once pledged, and upon which her husband now solemnly swears.

the nation's First Lady. At the dinner table, "we do something called 'roses and thorns,'" Michelle told *People*, "and we each share our rose and our thorn. Malia has pointed out to Barack that, as she said, 'Dad, you seem to have a pretty thorny job.' We looked at each other and laughed and said, 'It's okay, you can say that.'"

Michelle has not involved herself in her husband's very thorniest issues like the economy and the wars in Afghanistan and Iraq, but has, in the tradition of previous First Ladies, started staking out personal causes on which she promises to remain front and center. She indicated very early that she would focus on the concerns of families, particularly military families, and on those of working women. In January, one of the first bills President Obama signed into law was the Lilly Ledbetter Fair Pay Act, and immediately afterward Michelle hosted a White

House reception at which she said, "This legislation is an important step forward. It's also one cornerstone of a broader commitment to address the needs of working women who are looking to us not only to ensure that they're treated fairly, but also to ensure that there are policies in place that help women and men balance their work and family obligations without putting their jobs or their economic stability at risk."

A few days later, on February 2, Michelle made her first public policy advocacy trip and, pointedly, she did so with a visit to the Department of Education. There she told a group of employees, "I'm a product of your work," and openly lobbied for more education spending: "Imagine what we can do with millions of dollars more investment in this area. We can expand opportunities in low-income districts for all students, particularly for students with disabilities." Her husband, too,

said that his administration considers education a top-tier issue, and that greater investments of money and attention are needed. Where in the recession-plagued world the money would be found was, of course, a question worth asking.

Other initiatives undertaken by Michelle in her early months as First Lady boosted national interest in subjects as diverse as backyard gardening and Portuguese water dogs, not to mention sleeveless dresses.

As spring approached in mid-March, Michelle, accompanied by a gaggle of local primary school kids, took to the South Lawn of the White House armed with shovels and hoes—Michelle was shod for her day of digging in some very fashionable Jimmy Choo boots. The gardeners broke ground a few hundred feet from the mansion's kitchen on a plot that will, it is hoped, produce fennel, broccoli and spinach for the First Family's table. As can happen when a person is in an exalted position such as Michelle's, the renowned California chef and restaurateur Alice Waters, one of the country's most energetic advocates for homegrown foods, was consulted. Michelle let it be known that she was dead serious about her campaign to promote healthier eating habits in the American family. She also said that not only were Malia and Sasha expected to work in the garden but the President was, too.

Concerning the dog: Ever since Barack announced from the stage in Chicago's Grant Park on election night that his daughters' victory present in the White House would be a puppy, the question of what kind would be chosen caused more ink to be spilled in the American press than did the closing date for Guantánamo Bay or Iran's advancing nuclear capability. As Malia has allergies, the Obamas focused on breeds said to be hypoallergenic. There was, at one point, a flutter about a Labradoodle heading for the White House, but then Michelle said they would try to find a Portuguese water dog at a shelter. This immediately set off another round of controversy in the community of the canine concerned, with many pointing out that this energetic dog was a tough one for a first-time owner to handle. The Obamas were unpersuaded, and Bo, a gift from water dog–owning Ted Kennedy, officially arrived on April 14. Whose job it will be to train Bo to not dig in the new garden—never mind the big question of whether the President of the United States of America will be required to pick up after the pooch—is yet to be determined.

And, finally: the dresses. Michelle rises at 5:30 and works out in the White House gym before breakfast, as does her husband. The short of it is, her abs are firm and her biceps have definition and tone. Michelle has left no room for debate on this latter point as she has exhibited a now-famous penchant for sleeveless dresses; she wore one for the *People* magazine cover shoot and another when posing for *Vogue*; she wore one to her husband's speech to a joint session of Congress (which caused one Republican lawmaker to whisper to his neighbor, "babe"); she wore one for her official White House photographic portrait. Since every single thing that the First Couple does from sunup to sundown is scrutinized and parsed, this was, too—in spades. In an op-ed column in *The New York Times*, Maureen Dowd applauded Michelle's self-confidence and strength, while her op-ed colleague David Brooks urged Michelle to "cover up" if she wanted to be taken seriously. While the American jury might remain hung on this issue, there is little doubt that the 5-foot-11 Michelle's status as a fashion icon is of a level not seen in First Ladies since that of Jacqueline Kennedy. Thus far, it seems sleeveless dresses and cardigan sweaters are Michelle's pillbox hats.

And so, WITH NEW PETS AND NEW PROJECTS and new prospects, this thrilling new chapter continues in the extraordinary journey of the Obamas. With each waking day, Barack tries to steer clear of the cigarettes as he steers the ship of state. Michelle keeps their kids moving forward in the right direction as she tries to drum up support for her myriad causes. As has long been the case, they fill every day to the brim—then overfill it.

Their path to the White House could never have been predicted, nor, of course, can their future be foreseen in any detail. But one thing above all is clear: Just as Michelle and Barack hope for great things for their daughters, many of their fellow citizens anticipate great things from the two of them. Not just from him, from both of them. And from each of them.

Barack Obama will lead our country for four or eight years. His course seems, now, to be mapped. What problems and challenges he will face in this time will reveal themselves at regular intervals.

As for Michelle Obama—who can possibly say? She has achieved much already, that's for sure.

She is, in all likelihood, just getting started.

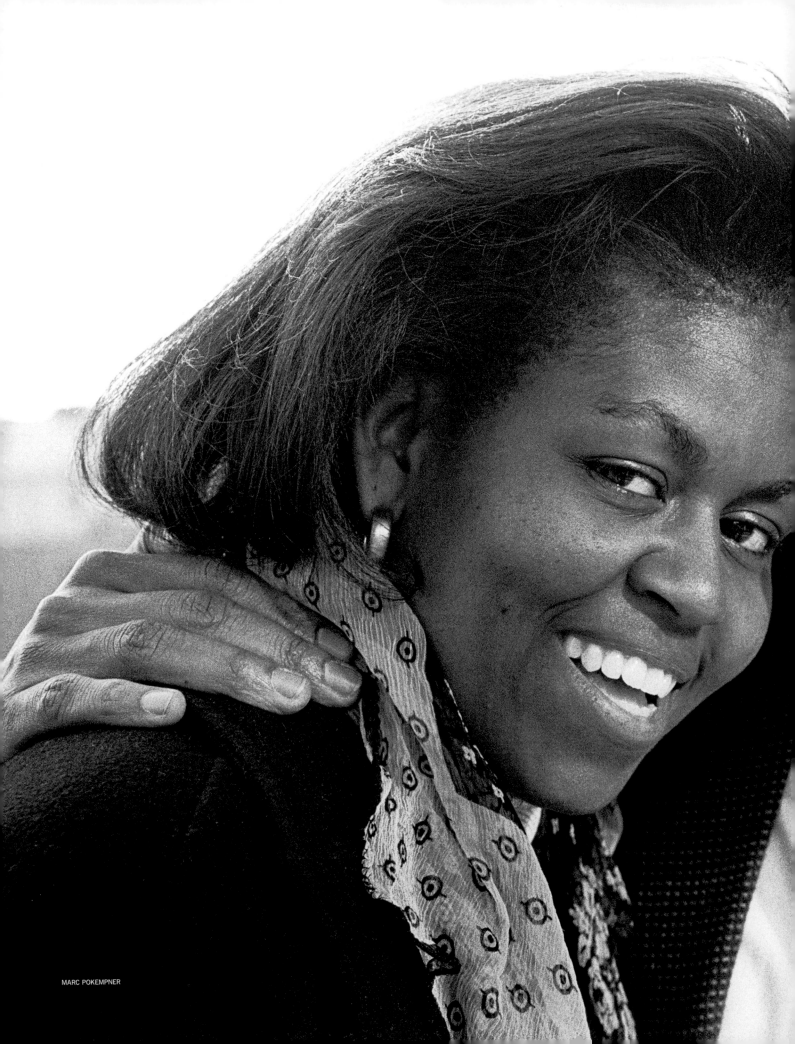
MARC POKEMPNER

This is the first official campaign portrait of the Obamas, issued in 1995 after Barack had announced his run for the Illinois Senate. He was 34 at the time; Michelle was 31. It is worthwhile to dwell on this picture for a second and consider how much this young couple had accomplished in terms of education, beating the odds and giving back—and how much they would do in the very near future. Only a decade earlier, they'd been spending their days in a world of ivied walls and ivory towers, preparing themselves for the reality outside. Within the decade to come, they would be thinking of the White House. The Obamas proved in that first campaign in Illinois that they were willing to engage in bare-knuckle politics— the only kind that succeeds in Chicago and that they were not only smart but also attractive to the electorate. All of this would serve them well in the years to follow.

SAUL LOEB/GETTY

PETER BARRERAS/ZUMA

When Malia (at right) was born in 1998, the Obamas were living in a first-floor unit at 5450 S. East View Park in a Hyde Park condominium complex (top). In 2005, with the royalties from Barack's best-selling memoir and the salary of Michelle's well-paying job supporting the purchase, they paid $1.65 million for a redbrick mansion with white pillars on Greenwood Street in the Kenwood district (bottom). The Obamas' new three-story home, which was built in 1910, featured 6,500 square feet of living space, six bedrooms, five and a half bathrooms and a four-car garage. Since moving to Washington, D.C., the family has kept the house, and the President has compared it to former President George H.W. Bush's Kennebunkport, Maine, retreat—indicating it may be used as a vacation White House during his term. A footnote: The purchase of the home and a vacant strip of land next door prompted controversy when it was alleged that the Obamas had been able to secure the vacant land for below-market value from a friend, an indicted—and subsequently convicted—wheeler-dealer named Tony Rezko. This story never died and delivered the young political couple an early lesson in how absolute probity must always be maintained.

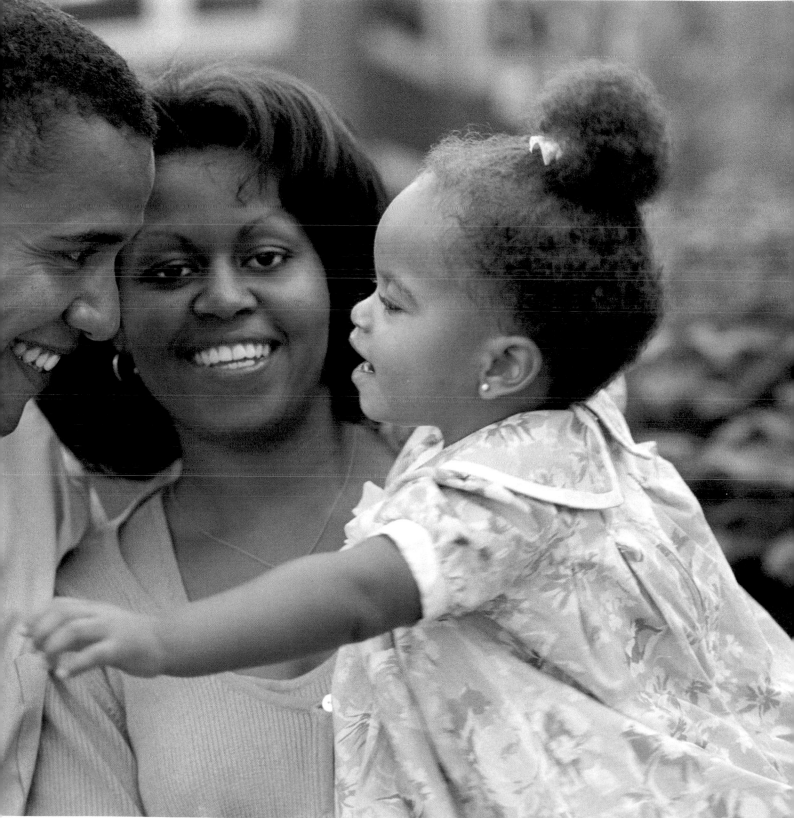

MARC POKEMPNER

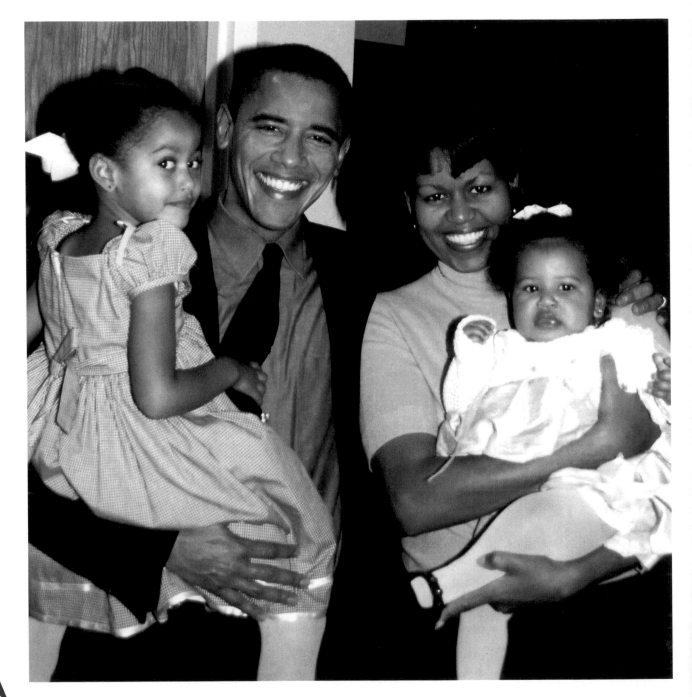

Above: On the day of their daughter Sasha's christening in 2002, Michelle and Barack pose with the baby and her older sister, Malia. Although he had alluded to Sasha's bout with meningitis in his memoirs, few outsiders realized just how serious the case had been until he talked candidly about it during an Internet town hall chat in March 2009. Opposite: Dad needs help blowing out the candles at his 43rd birthday celebration, which conveniently coincides with a political fund-raiser, on August 4, 2004, in Matteson, Illinois. This, too, is a photo worth pondering. The candidate is, in fact, merely the representative from the 13th district on Chicago's South Side in the Illinois Senate. But he is also the prohibitive favorite to win election to the U.S. Senate in three months' time. And he is now a national figure, having starred only days before at the Democratic National Convention—cameras are trained on his every move. This is another of those everything's-changing-for-the-Obamas pictures that happened so frequently in the first decade of the 21st century. On the pages immediately following, the family celebrates at the Hyatt Regency in Chicago on November 4, 2004. Mr. Obama is going to Washington—this first time, as a senator.

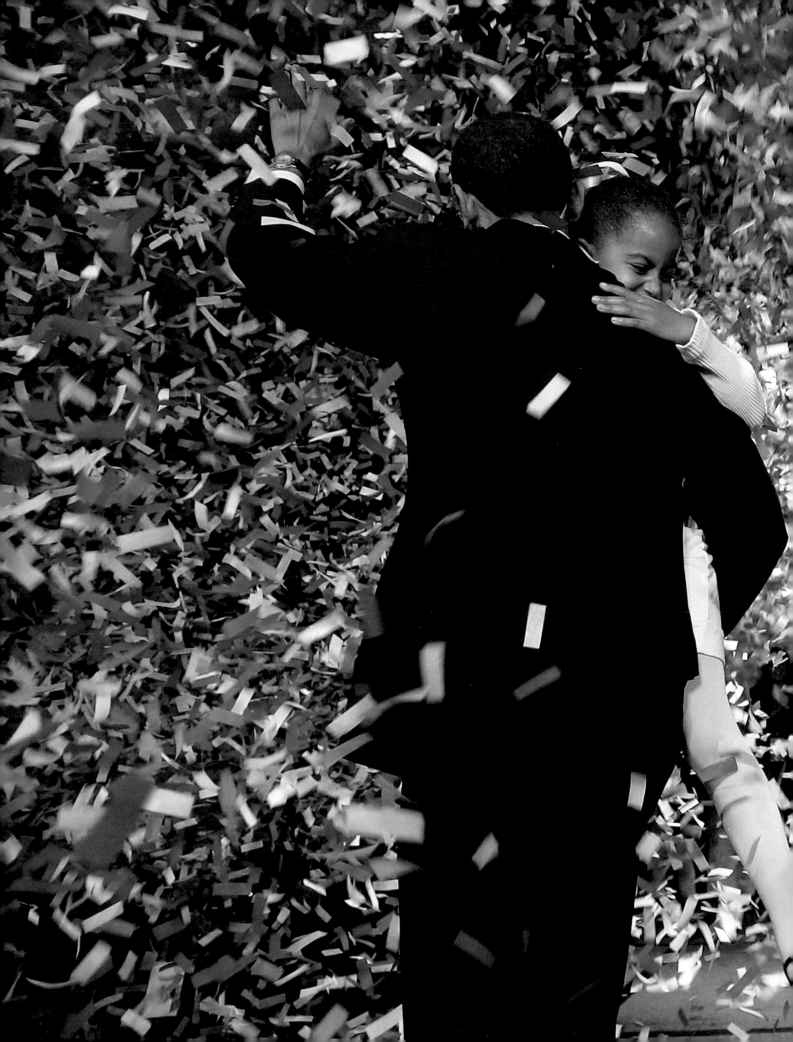

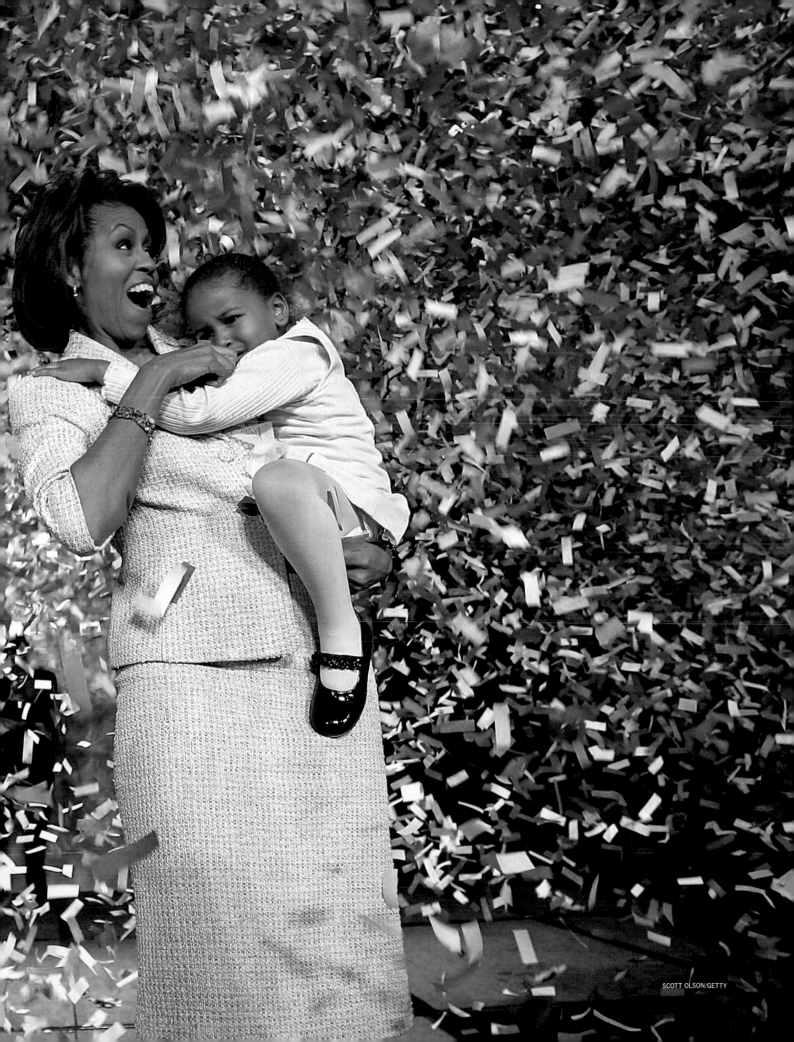

SCOTT OLSON/GETTY

By the time her husband ran for President, he was supremely confident in his various skills. When he would interview applicants for staff jobs, he would convey this surety. He let candidates for political strategist positions know that he thought he was a pretty fair political strategist himself. And he would let potential speechwriters know that, when it came to the final draft, he would be certain what speech he wanted to give and would have a strong hand in writing it. That said, he always leaned on Michelle. (And, it is to be presumed, leans on her still.) Here, in December 2004, having definitively become Mr. Keynote Address, the senator-elect from Illinois prepares for a night on the town with his wife. It is not to be an intimate night, but rather an appearance at the Economic Club of Chicago dinner, where, yes, he will deliver the keynote. In the moments following this run-through, Michelle will approve the speech (perhaps with suggestions), straighten hubby's tie, kiss the girls goodnight and head downtown to glad-hand—something she will get very used to doing in the weeks and months ahead.

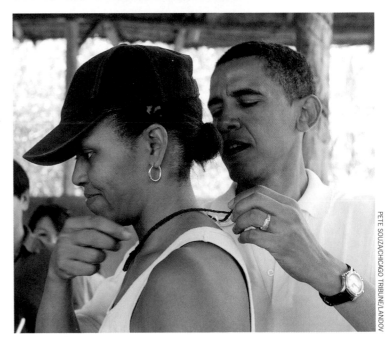

When the Obamas made a diplomatic trip to Africa in August and September 2006, their story was already enormous: They were attended by a trailing press corps, he was hailed as a conquering hero and all the talk back home was about how he might challenge Hillary Clinton for the Democratic presidential nomination. In Kisumu, Kenya, on August 26, there is a mob scene (above) as the Obamas arrive at a mobile clinic to take an HIV test (opposite), hoping to set an example for the tens of thousands of Africans who fear the stigma of being tested for AIDS, a disease that is ravaging sub-Saharan Africa. Right: Barack fastens the clasp on a new necklace presented to his wife in Masai Mara, Kenya, on August 30. On the pages immediately following, Michelle is escorted by security during a visit to Nairobi. Here, she will meet with the people of Kibera, the largest slum in Africa. Much has changed since she ventured to Kenya with Barack in 1992 to say hello, quietly, to a few of his relatives.

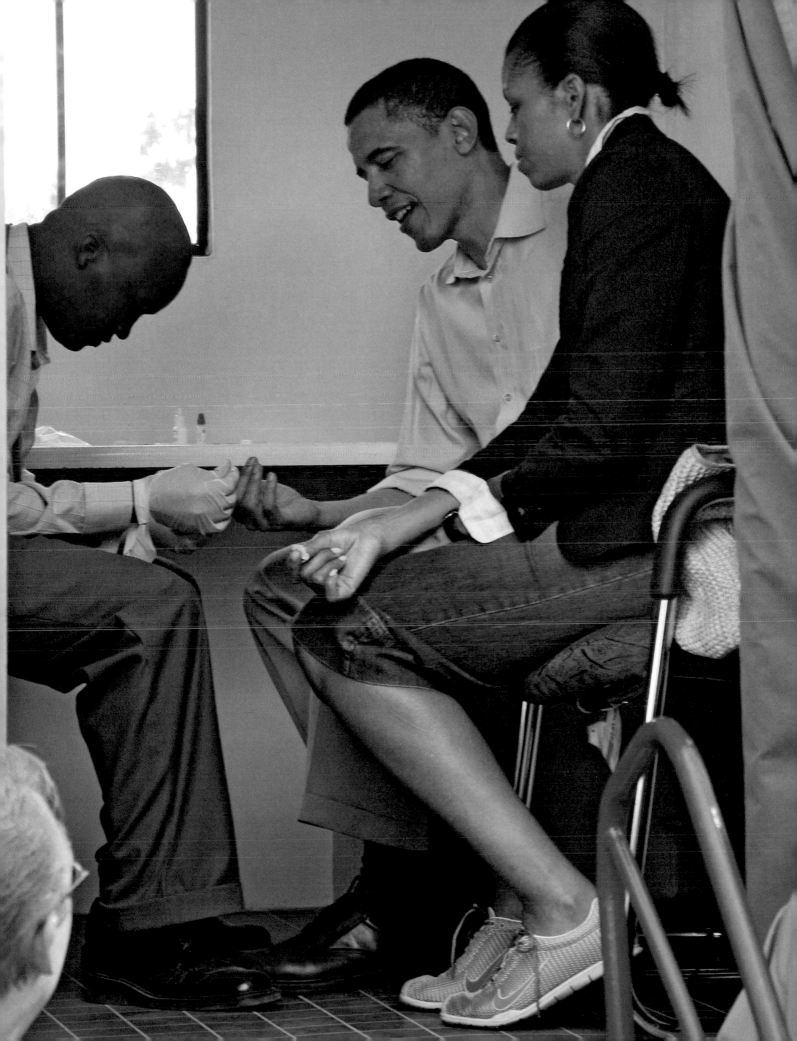

The date is February 10, 2007. The place is, very purposefully, the Old State Capitol Building in Springfield, Illinois, where in 1858 Abraham Lincoln had told his audience, "A house divided against itself cannot stand." In just a few moments—after Michelle makes him presentable, as we see—Barack and his bundled-up family will walk outside on this sunny but cold Saturday morning, and he will invoke Lincoln's words, then will continue, "As Lincoln organized the forces arrayed against slavery, he was heard to say: 'Of strange, discordant and even hostile elements, we gathered from the four winds, and formed and fought to battle through.' That is our purpose here today. That is why I'm in this race. Not just to hold an office but to gather with you to transform a nation." Thus ended weeks of intensifying speculation that Barack Obama would enter the race for President, and thus began months of sometimes exhausting campaigning for not only himself but Michelle, too, and even for their children.

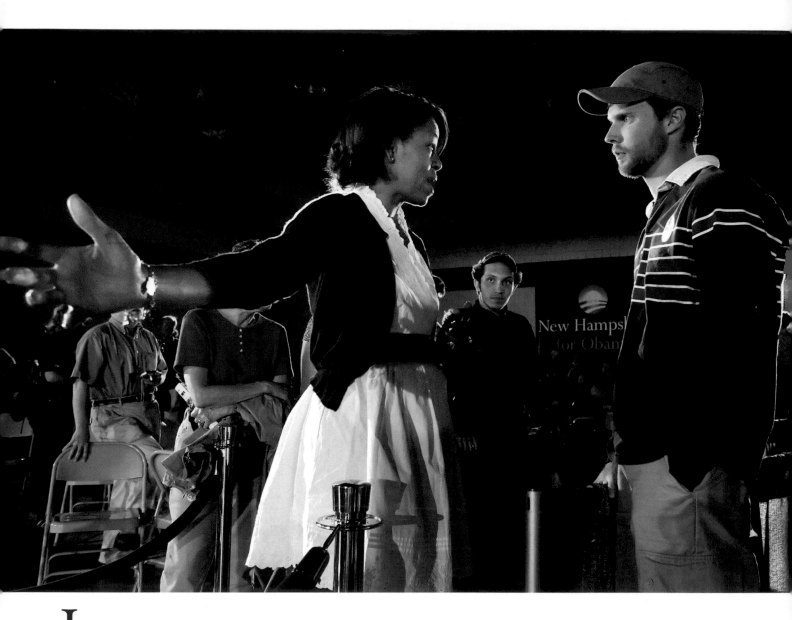

I f a person wishes to become President, that person goes, pronto, to New Hampshire and Iowa, states that stage, respectively, the earliest primary and the earliest caucus. On subsequent days in May 2007, Clan Obama is in the White Mountains of the Granite State, where Michelle starts introducing herself to the national electorate in Conway (above). The following day, the family moves farther north and west to the village of Bath—a veritable photo-op paradise. Currier & Ives or Norman Rockwell could not have painted Bath more perfectly than centuries of real life have: The one-lane covered bridge over the pristine Ammonoosuc River dates to 1832, and the locally famous Brick Store, seen on the opposite page, is nearly a half century older, and as authentic as any general store in New England. At the Brick Store, the kids can grab some licorice or root beer barrels while Mom and Dad load up on everything from Grandpa's Wonder Pine Tar Soap to maple syrup (try the Grade B) to a wheel of cheese to a weather vane; don't leave without a LIVE FREE OR DIE T-shirt, de rigueur summer wear in New Hampshire. When the candidate emerged from the Brick Store with a paper bag full of provisions, America (and Hillary Clinton) might have known that, excepting the occasional stumble (Exhibit A: bowling), his would be a pitch-perfect campaign. In the bottom photograph, Barack meets Bath police chief Dennis Mackay while Michelle and the girls are more taken with Laylah the beagle. In the photograph at top, Laylah faces the camera to have her brush with fame properly recorded for posterity. On the following pages: A game of cards as the campaign RV swings between stops in Oskaloosa and Pella, Iowa.

BRIAN SNYDER/LANDOV (3)

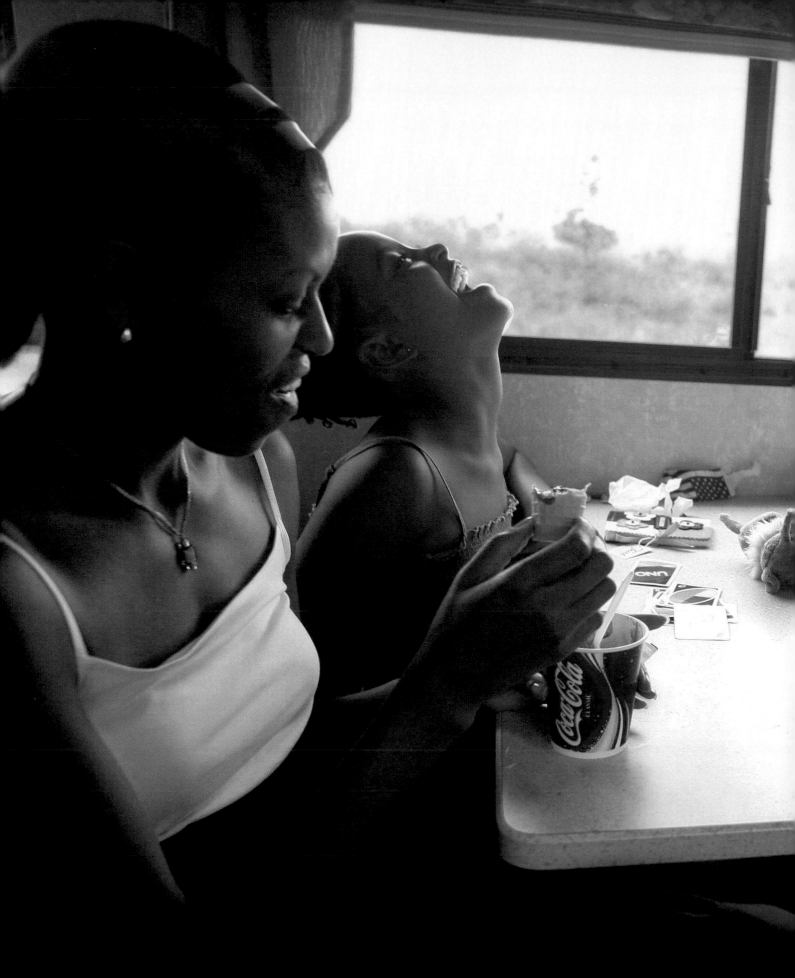

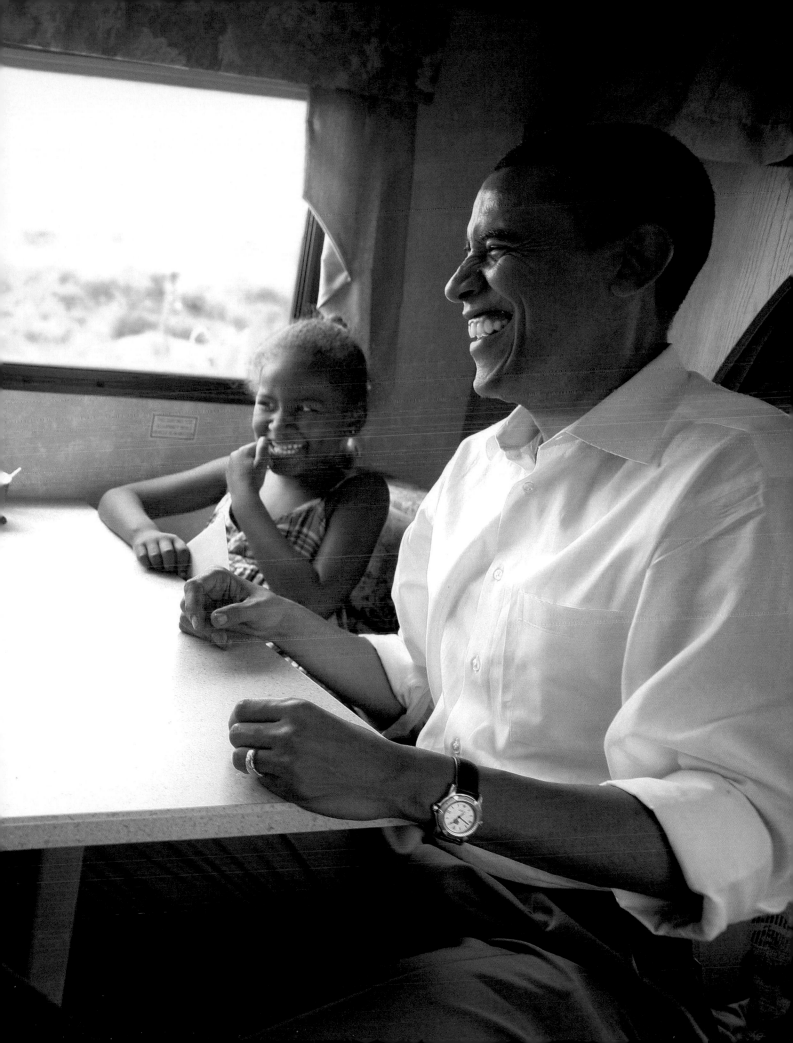

STEVE POPE/LANDOV

The Obama girls, particularly during the summer vacations of 2007 and '08, are afforded an extraordinary opportunity to see and learn about their country—and to have fun, as when Malia gets to hold a baby chick at the Iowa State Fair in Des Moines on August 16, 2007 (left). But as the expression on 6-year-old Sasha's face (above) indicates, life on the campaign trail can be tiring. It was Michelle (who is speaking in this picture, also taken in Des Moines) who would decide what was enough for her daughters and what was too much, and also the degree to which they should be in the public eye. The charming children were obviously an asset to the campaign, but there is a line of thought that youngsters can be harmed by the constant glare of the media. Michelle seemed to come down midway between Jackie Kennedy, who sought to shield her young children from the press, and Jack Kennedy, who invited photographers into the Oval Office when Jackie was away so that they could take pictures of Caroline and John-John scampering about. Opposite: In Waterloo, Iowa, Michelle signs a guest book at a house party. On the pages following: It is Mom who is beat as the campaign bus rolls between Hanover and Nashua, New Hampshire.

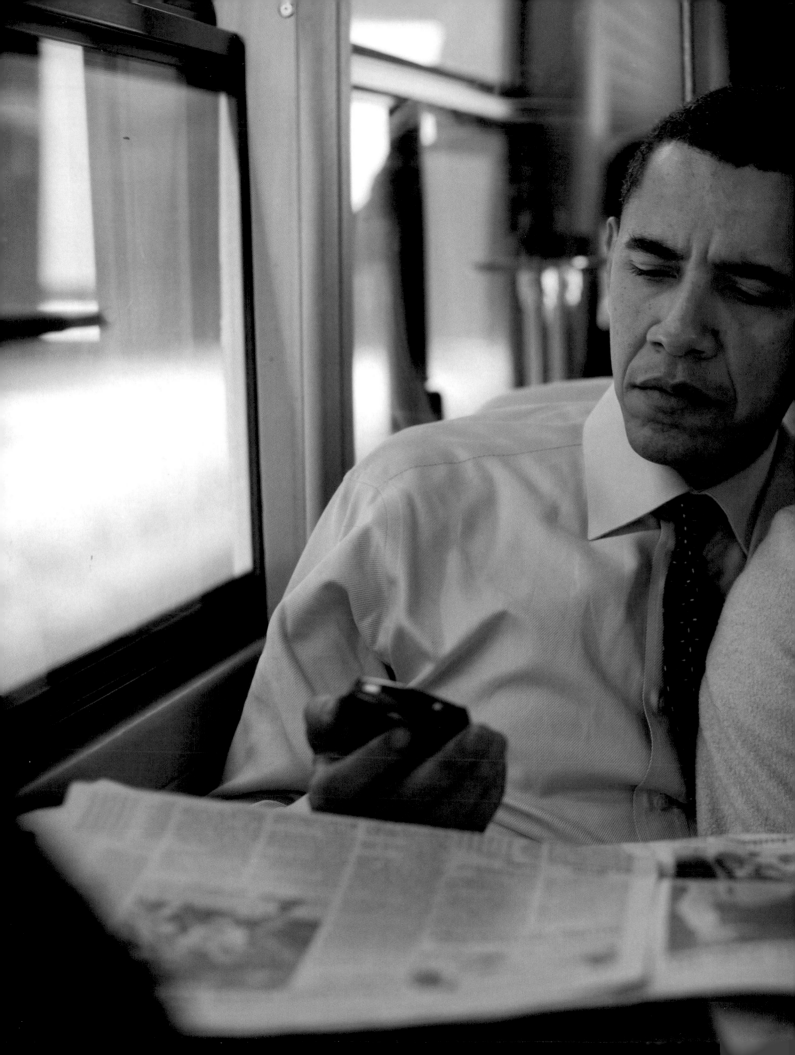

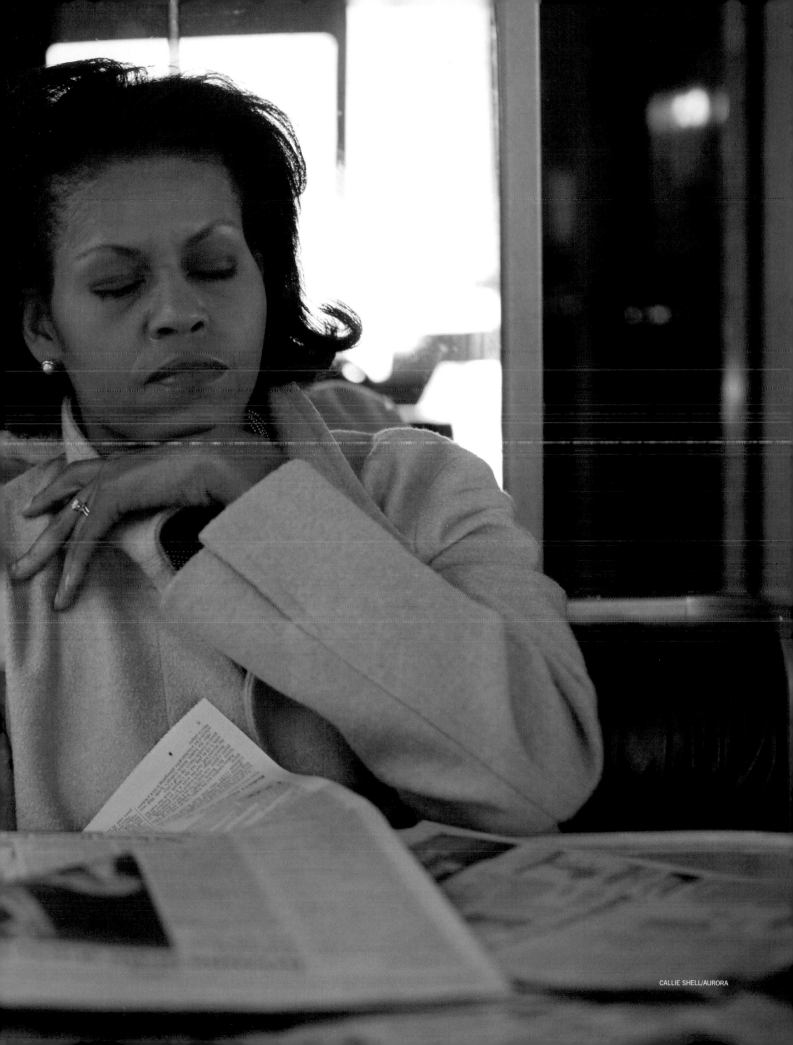

Certain stops along the way carried special resonance: When Michelle campaigned in South Carolina, speaking at a church that had been built in 1865 by freed slaves—perhaps her great-great-grandfather among them—she was engaged in a way that she might not have been at the next pancake breakfast in an endless stream of pancake breakfasts. Here, on May 3, 2008, in Kempton, Indiana, the Obamas battle a stiff breeze as they approach a house that Barack's great-uncle built more than 100 years ago. The Dunham family, as represented by Barack's maternal great-great-great-grandparents, had been pioneers in this region and had owned the land on which the house was built as early as 1847 or '48. It is an irony not lost on the Obamas that, while these particular Dunhams were not slave owners, others among his maternal ancestors were. Michelle, Barack and their children have all aspects of slavery represented in their heritage.

EMMANUEL DUNAND/GETTY

Du**uring the Indiana swing, Sasha and Malia court the youth vote in Elkhart (above), then jam in a session at the Great Skates roller rink in Lafayette (right). When the girls were part of the action on the trail, the Obamas scheduled the occasional "family day" of campaigning— light on policy speeches, political attacks and huge rallies, heavy on things that the sisters might enjoy (or could at least abide). For instance, the schedule this day saw the candidate talking at a suburban high school, which was followed by an appearance at a picnic. Then there was the visit to the house in Kempton that his great-uncle had built (a little family history for the girls) and finally an ice cream social at the roller rink. It was a different day than Sasha and Malia might have experienced back home in Chicago on any given Saturday, but when you figure in the birthday parties and playdates, the soccer games (Malia) and dance classes (Sasha), the tennis and piano lessons (both girls), then it was arguably no more hectic.**

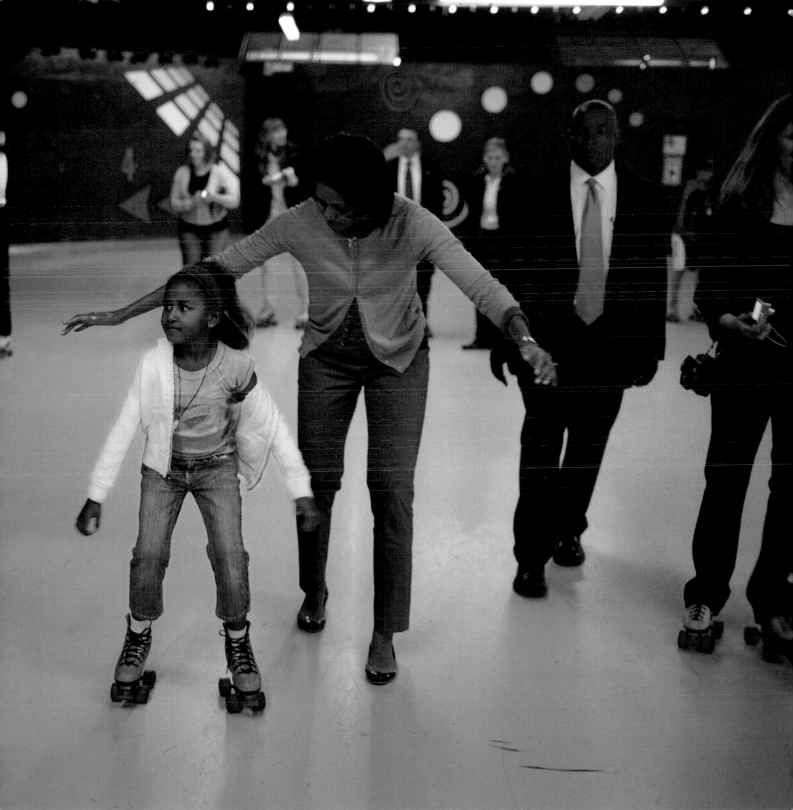

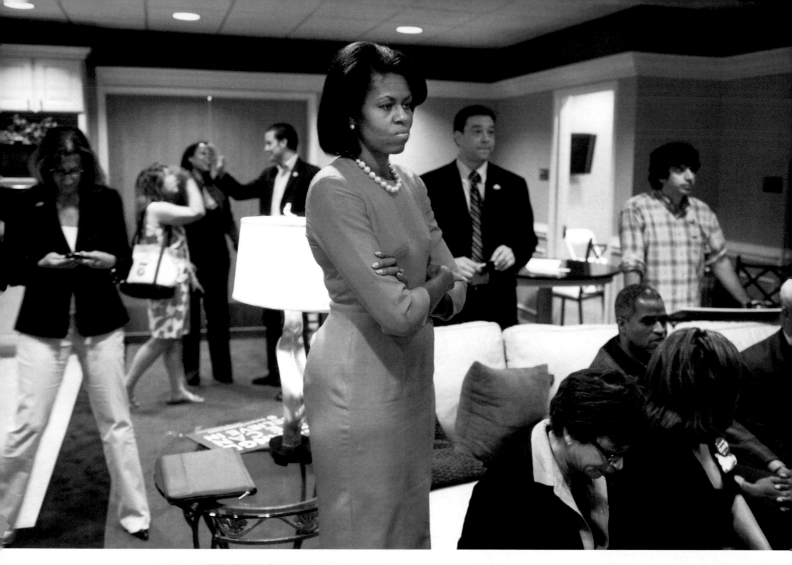
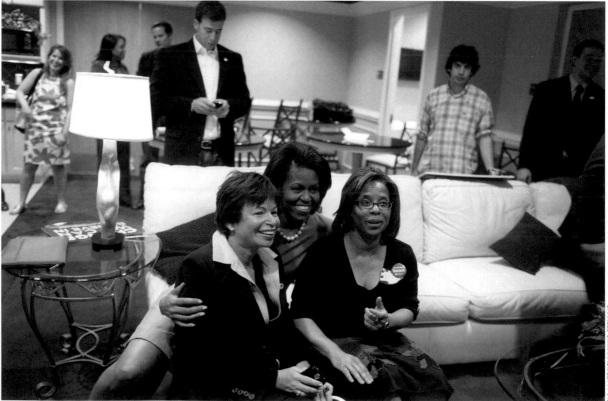

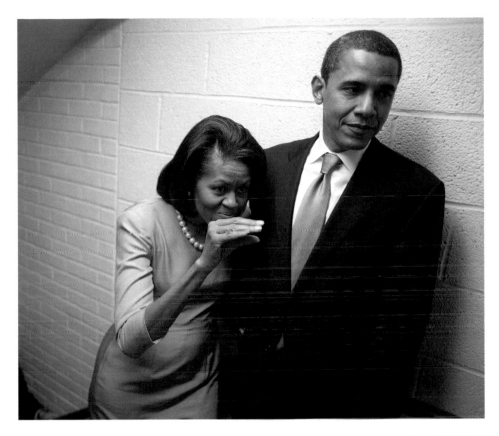

T hese photographs were all taken on May 6, 2008, before a rally in an arena at North Carolina State University in Raleigh. The Tar Heel State and Indiana are both weighing in this evening with primaries, and it is anticipated that the results will have great consequence for the Obama and Clinton campaigns—hence the tension on Michelle's face (opposite, top) as she watches returns come in. In the photograph opposite, below, she is happier as early news from North Carolina is good, and she gives adviser Valerie Jarrett (left) and Jarrett's law school friend Karol Mason a squeeze. On this page, top and bottom, she huddles with her husband just before he takes the stage. The race in Indiana, where Clinton is favored, remains tight all night, but in the morning it becomes clear that Hillary has held on. And so the road show continues. On the pages immediately following, Michelle watches as a crowd gathers outside the campaign bus for an event in Butte, Montana.

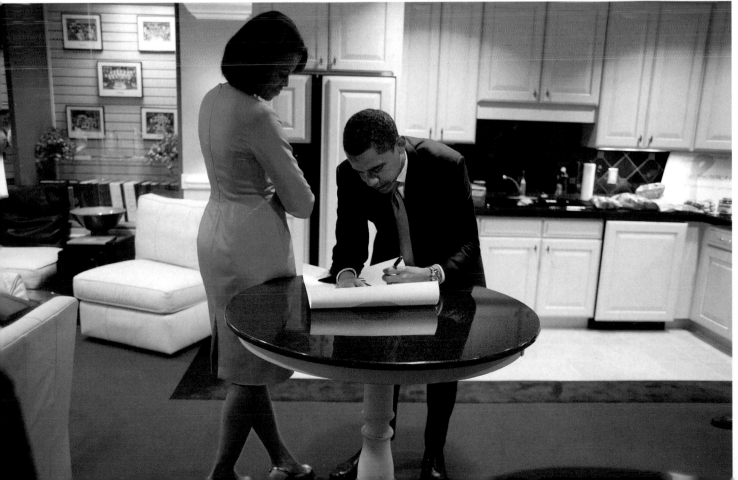

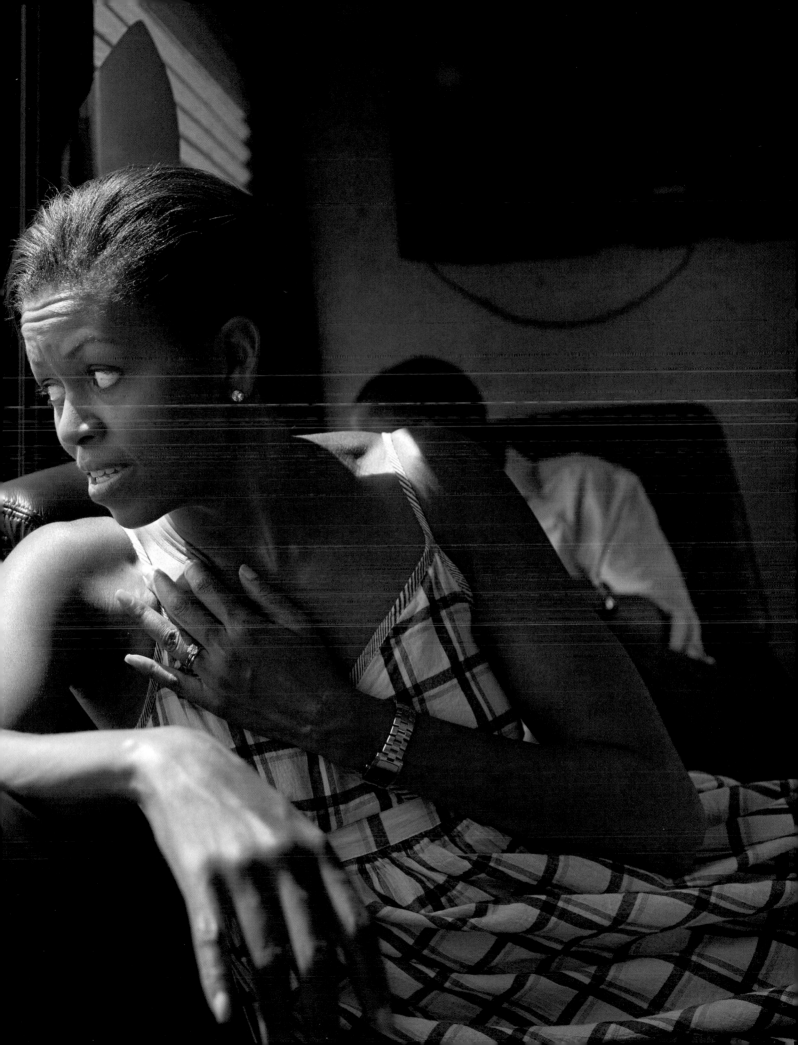

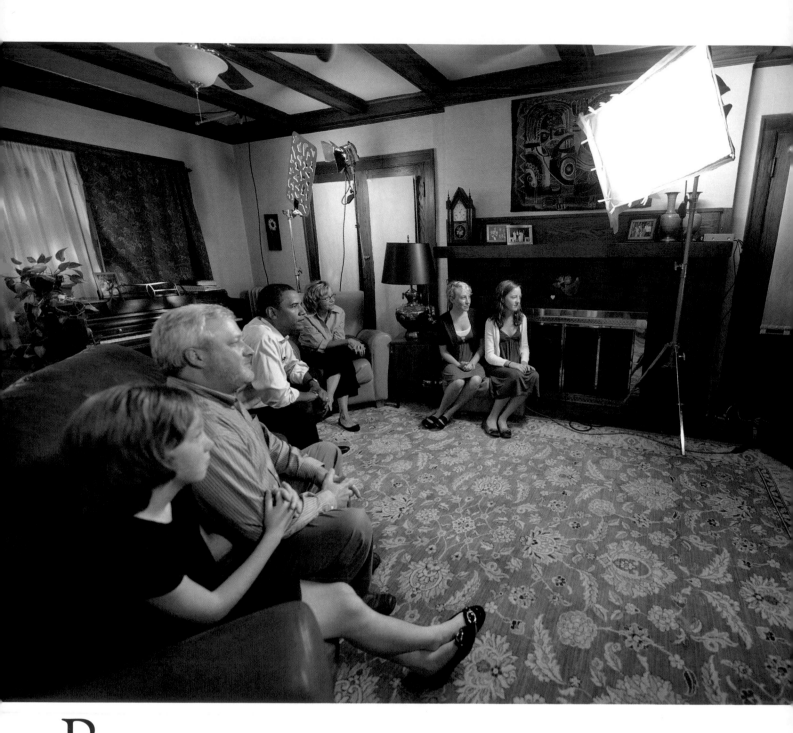

Barack Obama effectively clinched the Democratic nomination with the primary results of June 3, 2008, though Hillary Clinton conceded nothing initially and the campaign continued through the summer. But by the time the Democrats gathered in Denver on August 25 for their national convention, everything was settled and Clinton, who would later be tapped by President-elect Obama to be his secretary of state, was at her most gracious. The festivities at the convention got underway with emotional opening night speeches by Michelle and by Massachusetts Senator Edward M. Kennedy, who thrilled the crowd (Kennedy had recently been diagnosed with brain cancer). In the picture on the opposite page, top, Michelle embraces her brother, Craig, after he has introduced her to the delegates. Above: Barack, not yet in Denver but approaching there in carefully orchestrated stages, watches his wife's address from the home of Jim and Alicia Girardeau of Kansas City, Missouri; the girls in the photograph are the Girardeaus' three daughters. Opposite, bottom: When Dad appears on a video screen in the convention hall following Mom's speech, Sasha blows him a kiss. On the pages immediately following: After the tents have been struck in Denver, the Obamas breakfast with vice-presidential nominee Joe Biden and his wife, Dr. Jill Biden, at the Yankee Kitchen Family Restaurant in Boardman, Ohio, on August 30.

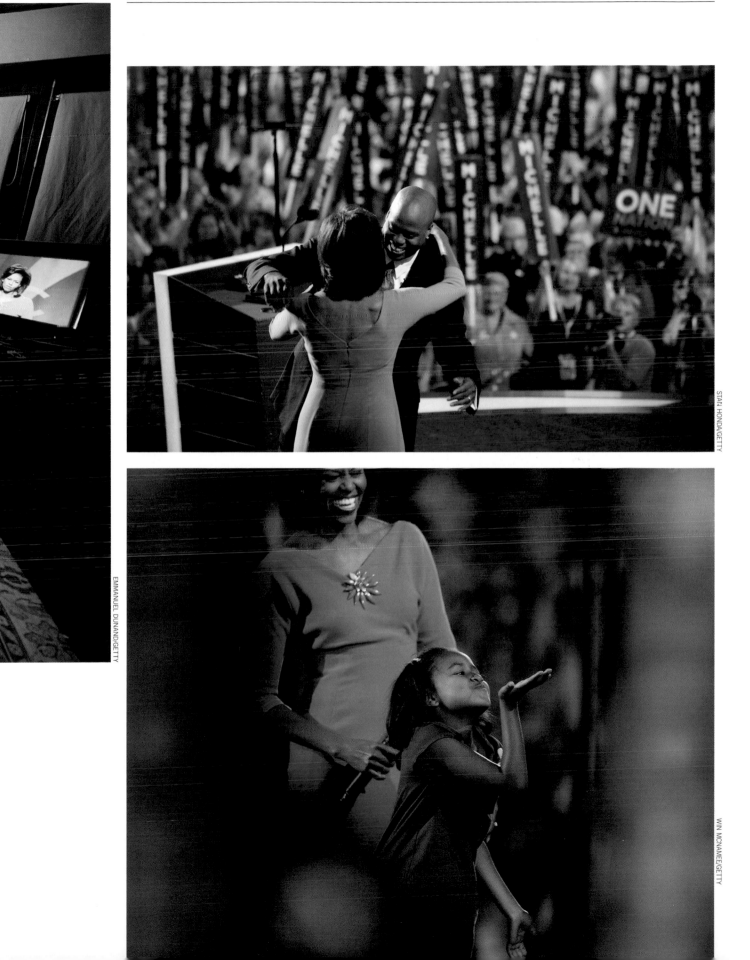

STAN HONDA/GETTY

EMMANUEL DUNAND/GETTY

WIN MCNAMEE/GETTY

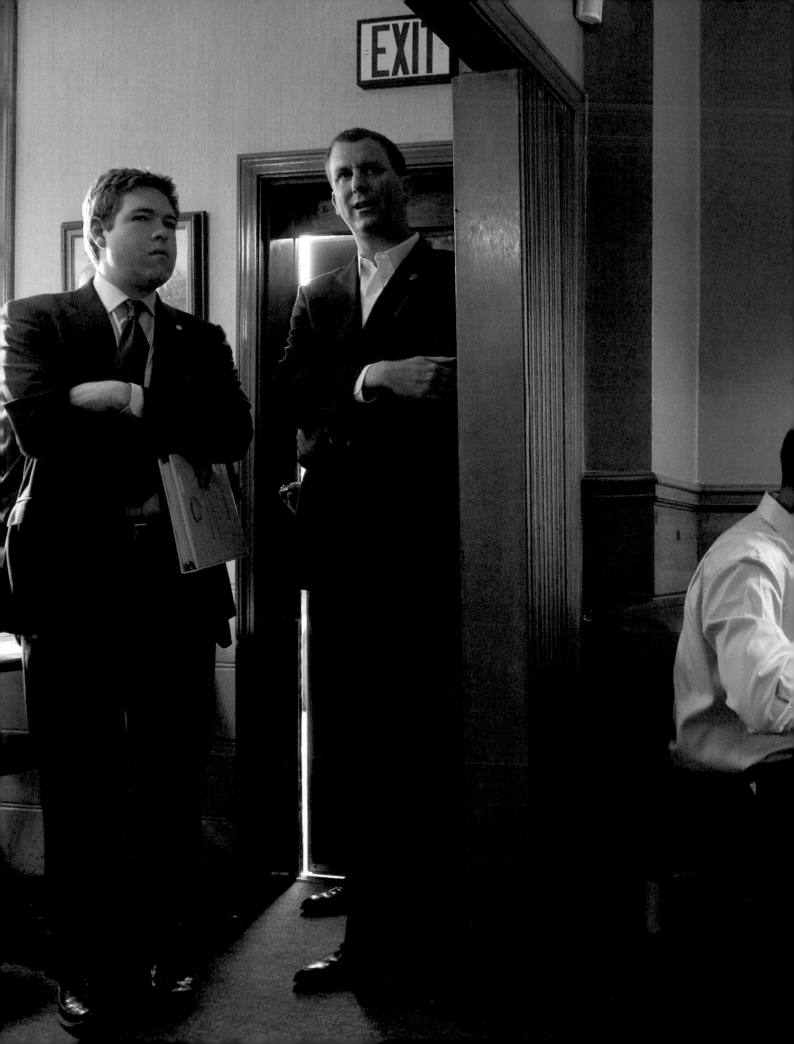

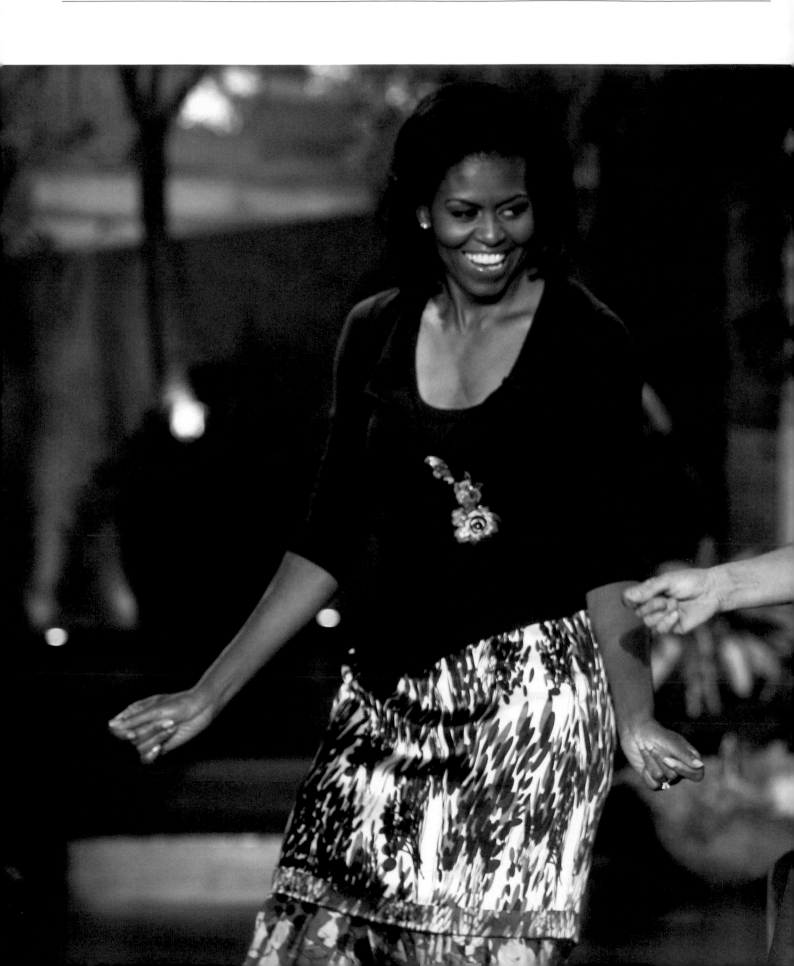

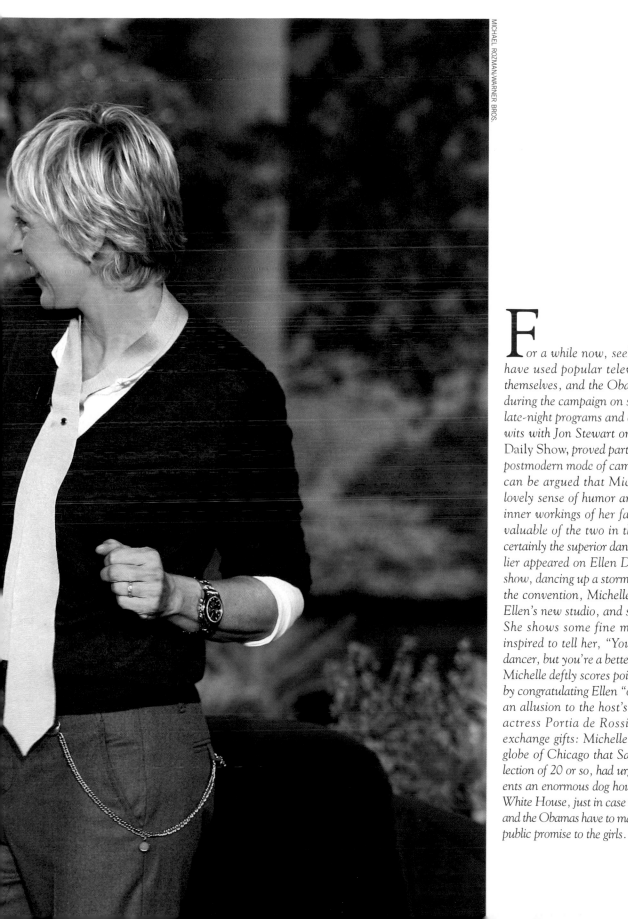

For a while now, seekers of higher office have used popular television shows to sell themselves, and the Obamas, who appeared during the campaign on several morning and late-night programs and even dared to match wits with Jon Stewart on Comedy Central's Daily Show, proved particularly adept at this postmodern mode of campaigning. In fact, it can be argued that Michelle, displaying a lovely sense of humor and talking about the inner workings of her family, was the more valuable of the two in this realm—she was certainly the superior dancer. Barack had earlier appeared on Ellen DeGeneres's popular show, dancing up a storm. Now, a week after the convention, Michelle is the first guest in Ellen's new studio, and she enters boogying. She shows some fine moves, and Ellen is inspired to tell her, "Your husband's a good dancer, but you're a better dancer than he is." Michelle deftly scores points in certain circles by congratulating Ellen "on your new move," an allusion to the host's recent marriage to actress Portia de Rossi. The two women exchange gifts: Michelle gives Ellen a snow globe of Chicago that Sasha, who has a collection of 20 or so, had urged. And Ellen presents an enormous dog house modeled after the White House, just in case the election goes well and the Obamas have to make good on their now public promise to the girls.

It is October 2008 now, and, if the polls are to be believed, signs are positive for the Obama campaign. The only two stories in America seem to be the economy and the election, and the media crush on the candidate is more intense than ever. Case in point: On October 3, Barack is campaigning in Pennsylvania with the intention of flying home that night to have a private 16th wedding anniversary celebration in Chicago with Michelle. It becomes known that he is headed for Penny's Flowers in Glenside, a small town outside of Philadelphia, and when he arrives, photographers are already crammed in behind the counter. "Hey, guys. How are you?" Obama asks. "I wish I could just slip in and get some flowers for my wife."

No such luck. As florist Mary Darcy helps him pick out a bouquet of white roses with baby's breath, every move is documented, despite the efforts of campaign aides to keep the swarm of shooters at bay. Michelle no doubt appreciated the flowers, and two weeks later enjoys another at least semiromantic evening with her husband backstage (opposite) at a "Change Rocks" fund-raising concert headlined by Bruce Springsteen and Billy Joel at New York City's Hammerstein Ballroom. Says Springsteen as he launches into "Born to Run": "This is for the senator!" At one point, Barack turns to Michelle and tells her, "Honey, the reason I'm running for President is I can't be Bruce Springsteen. I can't be Billy Joel."

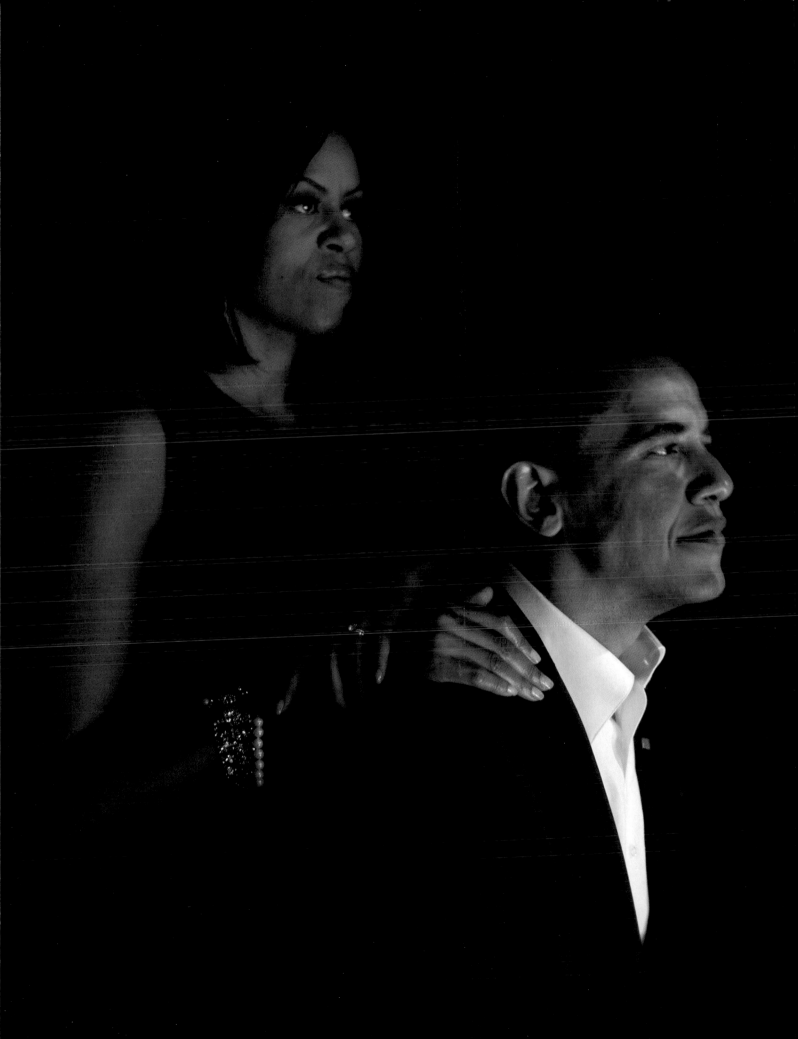

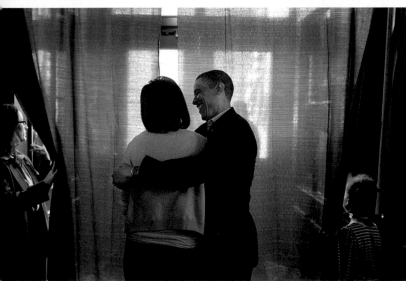

T wo days until the country votes, and it's all good for the Obamas. The behind-the-scenes photographs above are the kind that the campaign doesn't like to see published at the immediate point in time because they reflect, too obviously, a true mood: confidence, happiness, certainty. This is not a family—or a team—that thinks it has any chance of losing. The Obamas will be working Ohio cities on this eve of the election. In the top photo, the women (the girls are now 7 and 10 years old) goof around backstage before a rally at the Cleveland Mall (while on the main stage, Bruce Springsteen will again do his bit for Dad, making for a mob scene). In the photograph beneath, Michelle and Barack spend a quiet moment together at the State House in Columbus, but cannot suppress smiles. Sixty thousand supporters are waiting outside, and Springsteen isn't even coming to this gig. Barack has become a superstar in his own right, as has Michelle (right, on the steps of the State House). America has come to know her, and America has fallen for her.

JOE RAEDLE/GETTY

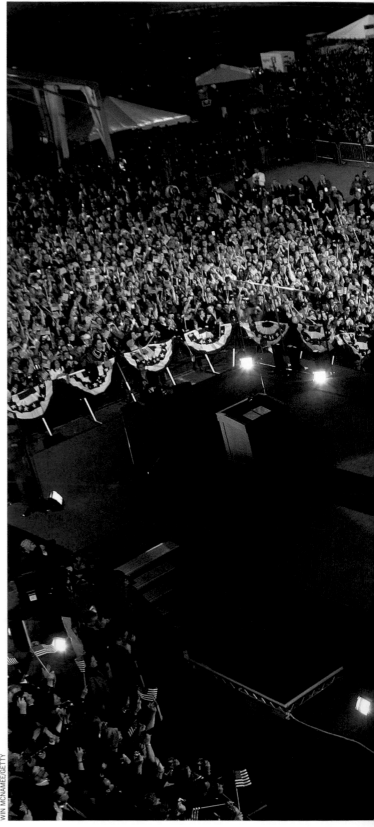

WIN MCNAMEE/GETTY

November 4, 2008: A date that will go down in American history. The enthusiasm for this unprecedented election was immense; about a third of eligible voters made sure they would be counted by voting early or by absentee ballot, and in the morning hours of the fourth, long lines began to build at polling places in cities and towns across the land. The nationwide turnout would be the largest in a century as two-thirds of registered voters exercised their rights. When their collective voice was heard, it became clear: Barack Obama had won, and won big. He had won in places like Indiana, where Democrats had struggled to win for years, and in places like Virginia, where, once, it would have been unthinkable that a black presidential candidate could win. He won, and then he exulted with his family on the stage at Chicago's Grant Park. In the photograph at right are Michelle, Malia, Sasha, Barack and some 240,000 of their closest friends and neighbors who have gathered to celebrate this night. Barack delivers his famous and moving "Yes We Can" speech to this joyful throng, but the biggest takeaway seems to be his emphatic reiteration of that pledge to the kids: Yes we can . . . have a dog in the White House. The great and consequential debate begins: Which breed? The American Kennel Club will weigh in, and so will advocates of dog-pound adoptions. In the above photograph are the proud mothers who lived to see this historic day: Marian Robinson, whose house is still right nearby, with her son-in-law, Barack; and Jean Biden, with her son Joe.

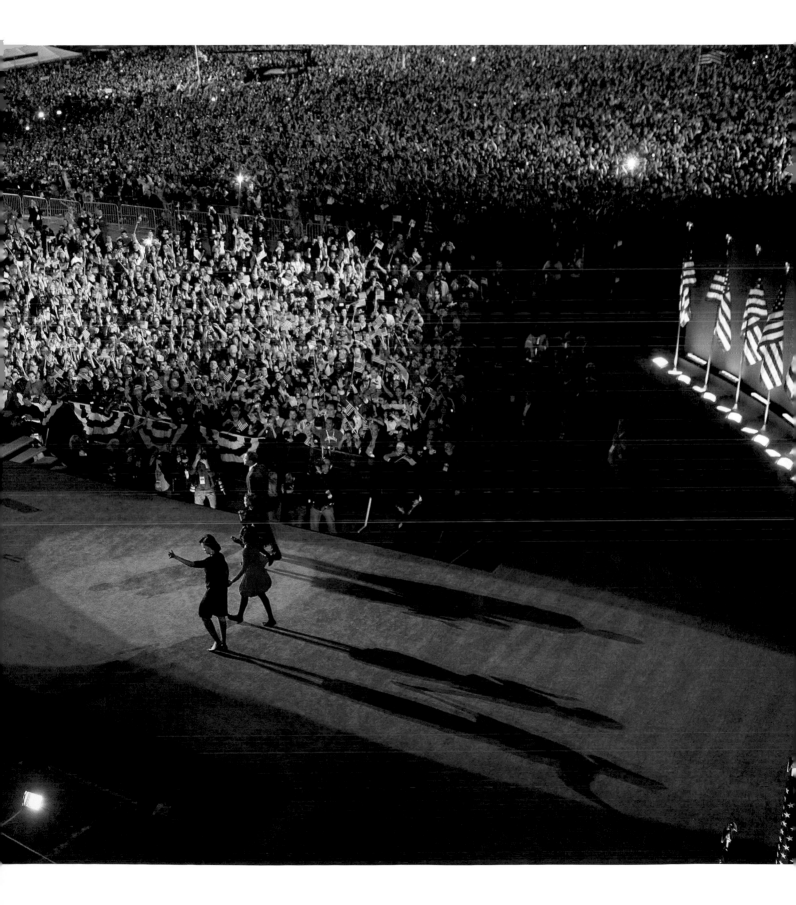

Between November 5, 2008, and January 19, 2009, as the President-elect goes through the formal process known as the Transition—picking Cabinet members, receiving secret codes and procedures from the team of the outgoing President, George W. Bush, and generally learning the ropes—all of the Obamas find themselves in transition. The photograph above was taken on January 5 at the Hay Adams Hotel in Washington, D.C., where the family is living temporarily before moving into Blair House, thence to the White House. If a mix of eagerness and anxiety shows on the girls' faces, that is to be expected, for this is the day they head off to their new school, Sidwell Friends. No child in a First Family has attended Washington's public schools since Jimmy Carter's daughter, Amy, in the 1970s, but some people had thought that because Michelle was the proud product of a public school system,

the Obama girls might. This was, however, not to be. In the other photograph seen here, on January 19, the evening before the presidential inauguration, Michelle and the girls whoop it up at a novel event, the "Kids' Inaugural: We Are the Future." It should be noted that in this picture they are not going wild for Miley Cyrus or the Jonas Brothers or any of the other acts that perform at the concert (though they will surely do this), but rather for U.S. troops being saluted onstage. Sasha and Malia will shortly learn, in their earliest days in the White House, that there are perks indeed to being First Kids. During a sleepover with some friends from their new school, their mom will oversee a scavenger hunt that leads ultimately to a certain door. When that door is opened, who is lurking within but the three Jonas boys, gilded idols of all American girlhood. It is good to be the daughters of the king!

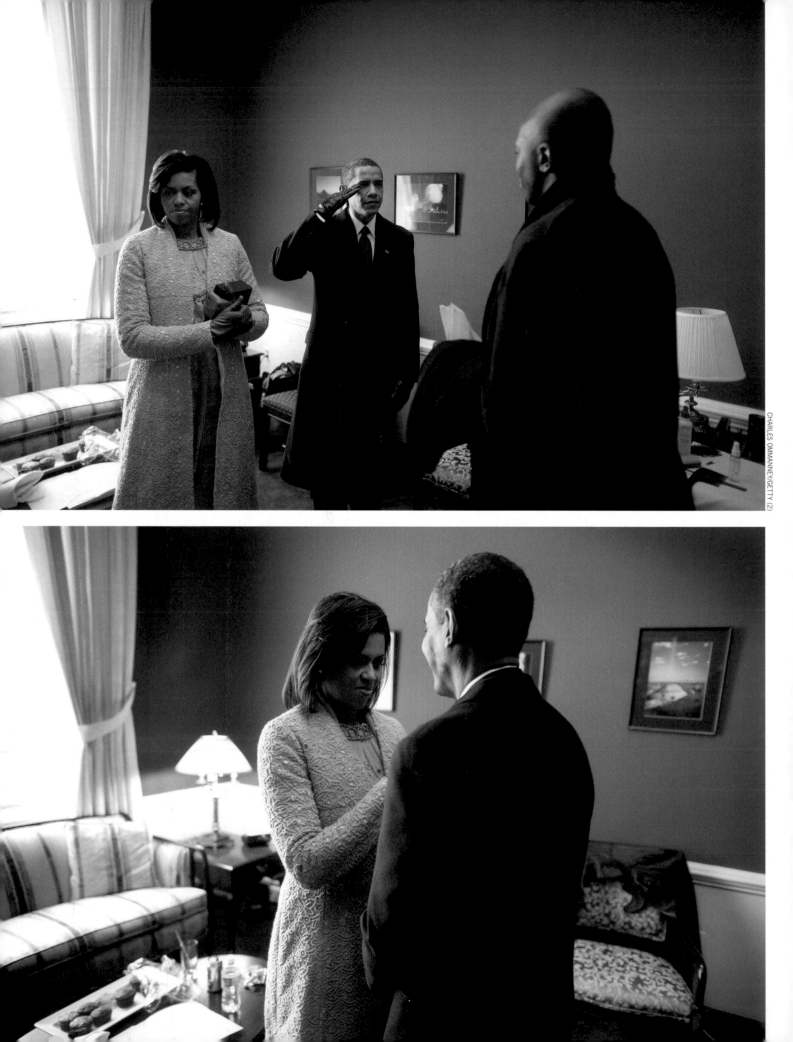

January 20: the big day. As lines form at 4 a.m. in suburban parking lots surrounding the capital city, with thousands of people ready to hop trains that are scheduled to begin running early to accommodate a crowd that will swell to 2 million, the Obamas stir in Blair House. While the D.C. fire department and emergency services crews are responding to scores of calls from people who are freezing—temperatures are in the twenties—the Obamas attend a private service at St. John's Episcopal Church, the so-called Church of the Presidents. Then, along with the Bidens, the Obamas enjoy coffee at the White House hosted by the Bushes and the Cheneys. At 10:50, a motorcade transports them all to the Capitol. Now, in the photographs opposite, Michelle, Barack and his aide, basketball buddy and principal bodyguard Reggie Love, are in a holding room in the Capitol building; in the top picture, Barack practices the salute he will use today and passes muster with his wife and his friend. Below: At noon, Barack Obama, by law, becomes the 44th President of the United States of America, and five minutes later (the ceremonies are running just a bit late), he places his hand on the Bible held by his wife to be sworn in by U.S. Supreme Court Chief Justice John Roberts. Malia and Sasha look on. He then delivers his strong and somewhat stern inaugural address calling for fortitude in difficult times. Tears of joy and pride are shed, particularly by black Americans in the audience. The Obama inauguration will stand historically with the biggest events ever staged in the nation's capital—such events as, many people note today, Dr. Martin Luther King Jr.'s 1963 March on Washington.

CHUCK KENNEDY/GETTY

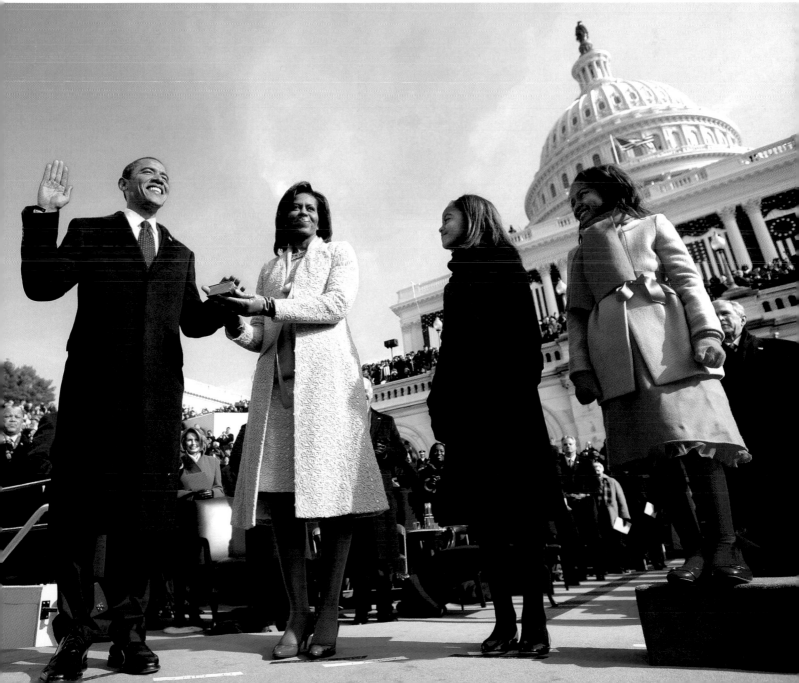

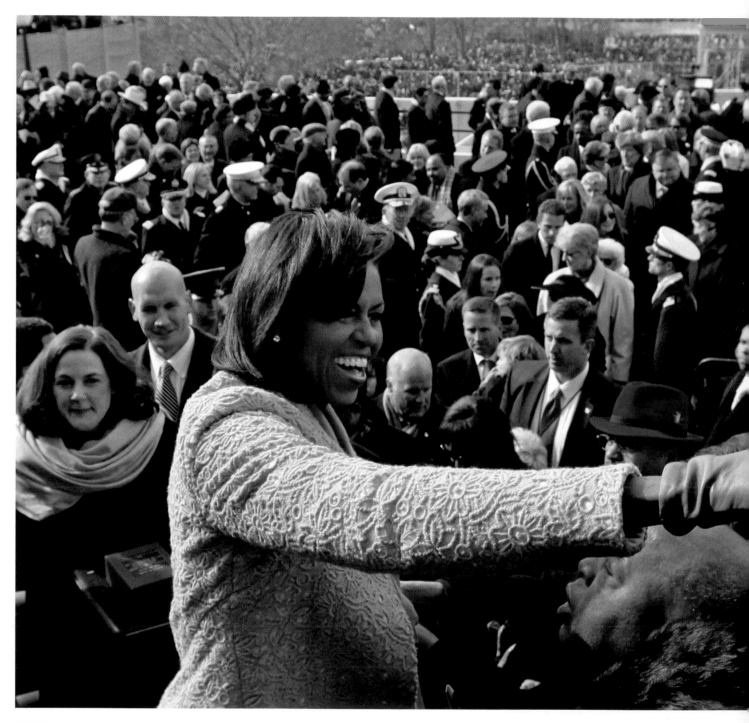

Everything Michelle will ever wear again will be parsed by a style-obsessed public, and the yellow outfit spurred a ruckus on the Internet. "She seems to wear yellow a lot!" "She apparently likes yellow!" "How do you feel about yellow?" "A little bulky? . . . And . . . yellow??" Only a First Lady could inject a color into the national conversation. (By the way, most folks thought the dress and matching coat ensemble, made by Cuban-born

Isabel Toledo, was stylish, sensible and fine.) Above: Michelle reaches out to the throng near the Capitol before she and her husband join the parade down Pennsylvania Avenue to the White House. In the top right photograph, President Obama kisses his mother-in-law, Marian Robinson. In the bottom picture, the First Lady speaks with Barack's stepmother, Kezia, who has flown with other relatives from overseas for this special day. During

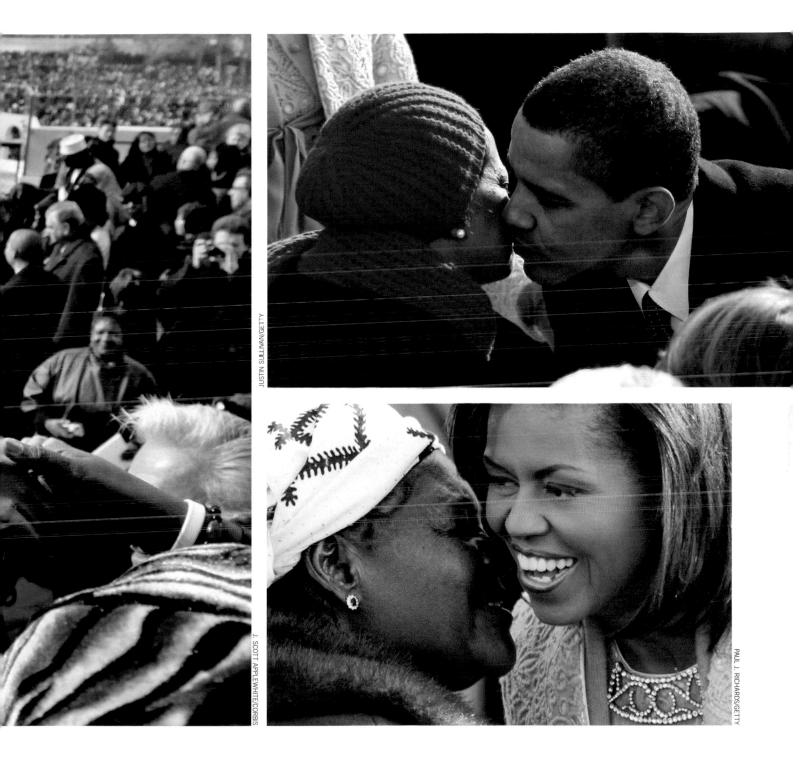

JUSTIN SULLIVAN/GETTY

J. SCOTT APPLEWHITE/CORBIS

PAUL J. RICHARDS/GETTY

the procession to the White House, the Obamas will spend much time waving from behind the windows of "the Beast"—the most heavily armored limousine in the world—with intermittent periods of walking in the open air. This has nothing to do with the cold weather. The security in the city today is without precedent. That terrorists might target American inauguration activities is clear to all, and that others might violently resent the first black President is equally apparent. In fact, throughout the day, law enforcement agencies continue to investigate a potential threat from an East African Islamist group—though intelligence officials stress that this new item on their radar is of "limited specificity and uncertain credibility." Nothing does, in fact, come of it, and the long, magical afternoon progresses with much pageantry and without incident. And then: On to the balls!

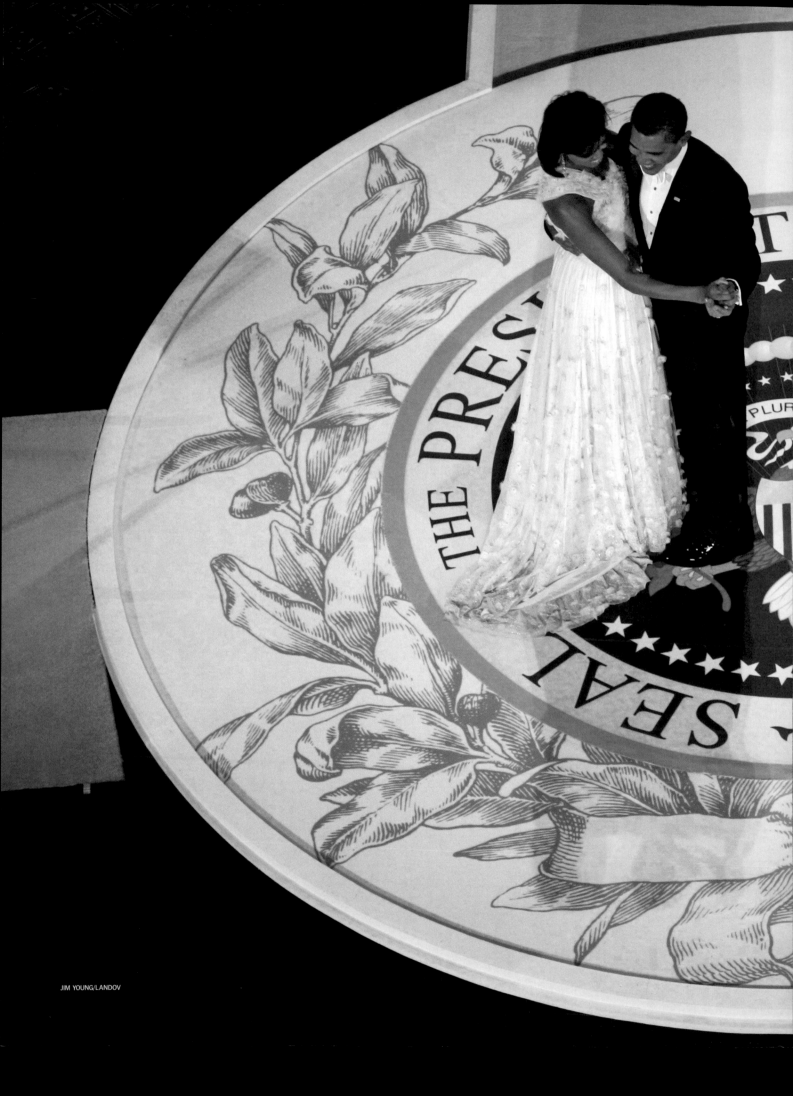

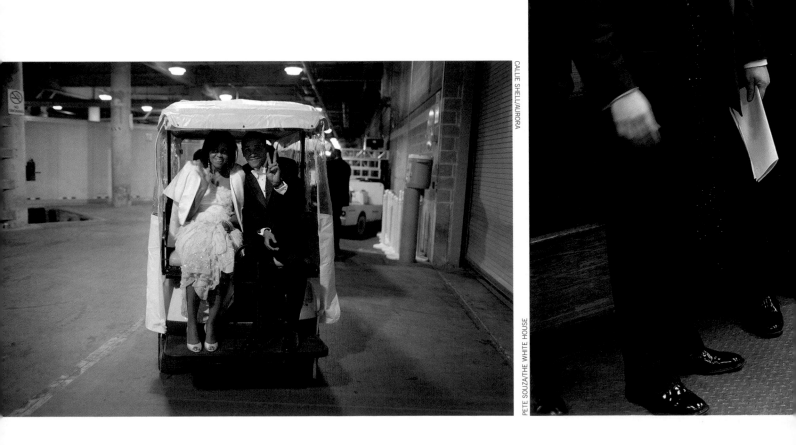

CALLIE SHELL/AURORA

PETE SOUZA/THE WHITE HOUSE

O n the previous pages, the First Couple trip the light fantastic on a replica of the presidential seal during the Commander-in-Chief's Inaugural Ball. Above: When you're going to dance at each of 10 events that you are attending, more than half of which are at the Walter E. Washington Convention Center, it is perfectly O.K. to accept transport from one to the next rather than hoof it. In the picture at right, Barack has gallantly draped his tuxedo jacket around Michelle for warmth as they put their heads together in a freight elevator at the convention center. It is 11 p.m., and they are headed to the fifth gala on the agenda. As aides and secret service agents busy themselves, the Obamas discuss the relative comfort of their shoes. The first dance they attended this evening was the Neighborhood Inaugural Ball, a new idea in that it was open to the public. As Barack explained: "I cut my teeth doing neighborhood work, and this campaign was organized neighborhood by neighborhood. . . . This ball

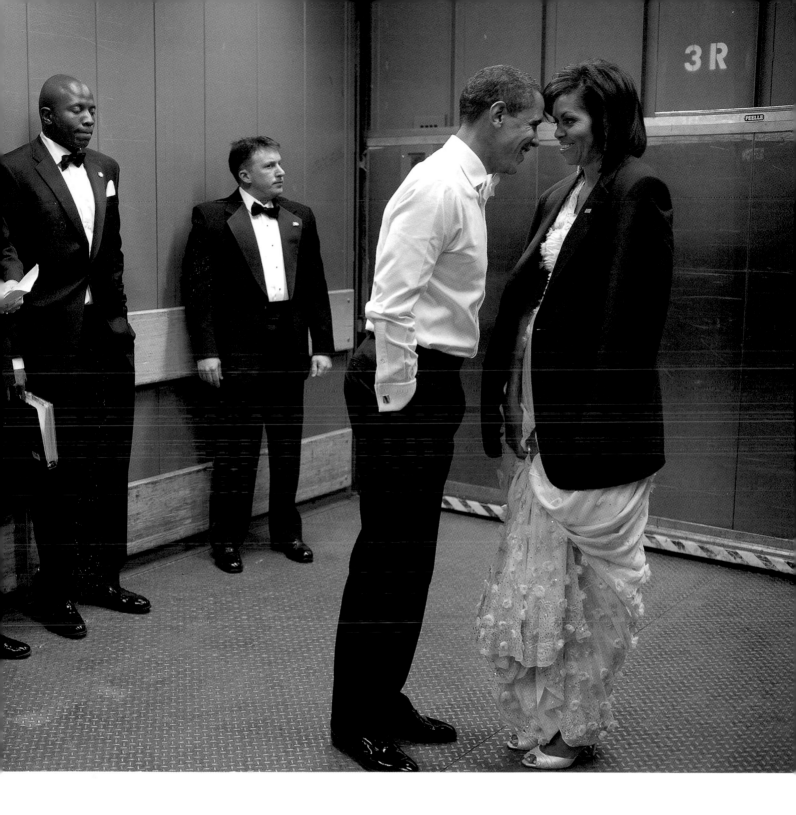

is the one that captures best . . . the spirit of this campaign." The crowd at that raucous ball went wild when the Obamas entered the room. "First of all," the President said, "how good-looking is my wife?" She was good-looking indeed—always has been—though fahionistas around the world continued their daylong dissection of her wardrobe. The First Lady had chosen, from among several dresses made especially for the occasion and submitted by various designers, a long gown of ivory silk chiffon, embellished with organza, Swarovski crystal rhinestones and silver thread embroidery, fashioned by 26-year-old Jason Wu. "It's thrilling," said Wu, who didn't know Michelle had selected his creation until she showed up wearing it. "I couldn't ask for any more than this." He went on to explain that the gown was meant to capture the Obamas' moment: "It's about hope. It's about newness. It's all a little dreamlike, and we're making history, and I wanted to really reflect that." Yes, well: It was a very nice dress.

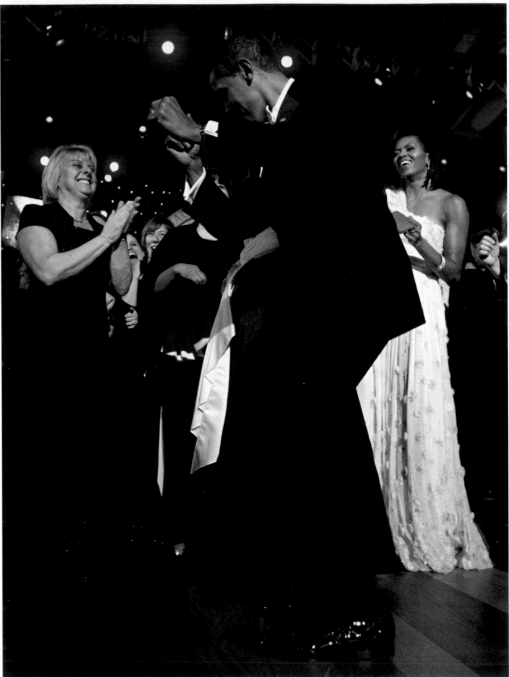

Their first spin around the floor on this long, long evening began at 8:30 p.m. at the Neighborhood Ball. They danced to the Etta James song "At Last," as performed for them by the singer Beyoncé. Later during the ball, which also included live entertainment by such artists as Jay-Z, Faith Hill, Shakira and Alicia Keys, the President cuts loose with vigor (above) as his wife applauds the performance. Expending this kind of energy so early in the evening may have been unwise. On the opposite page, we see Michelle resting her feet at 11:30 p.m. before attending the Western Ball in the convention center; the poor dear still has another three to go. At the Western, singer Marc Anthony will entertain the First Couple plus 11,500 other folks, including several Hollywood types. Director Ron Howard is happy for the Obamas, of course, but as he observes their progress through the endless night, he sympathizes: "This has got to be the grueling part for the First Family." At the eighth ball, the Midwest, the President shows some earnest sympathy as well, introducing Michelle by saying he is about to "dance with the one who brung me, who does everything I do—except in heels." Those heels are put to work for the final time shortly after 12:35 a.m. on January 21 at the Eastern Inaugural Ball. Not very long thereafter, the extraordinary day draws to its close, and the Obamas, on their first night at the White House, sleep the sleep of the just.

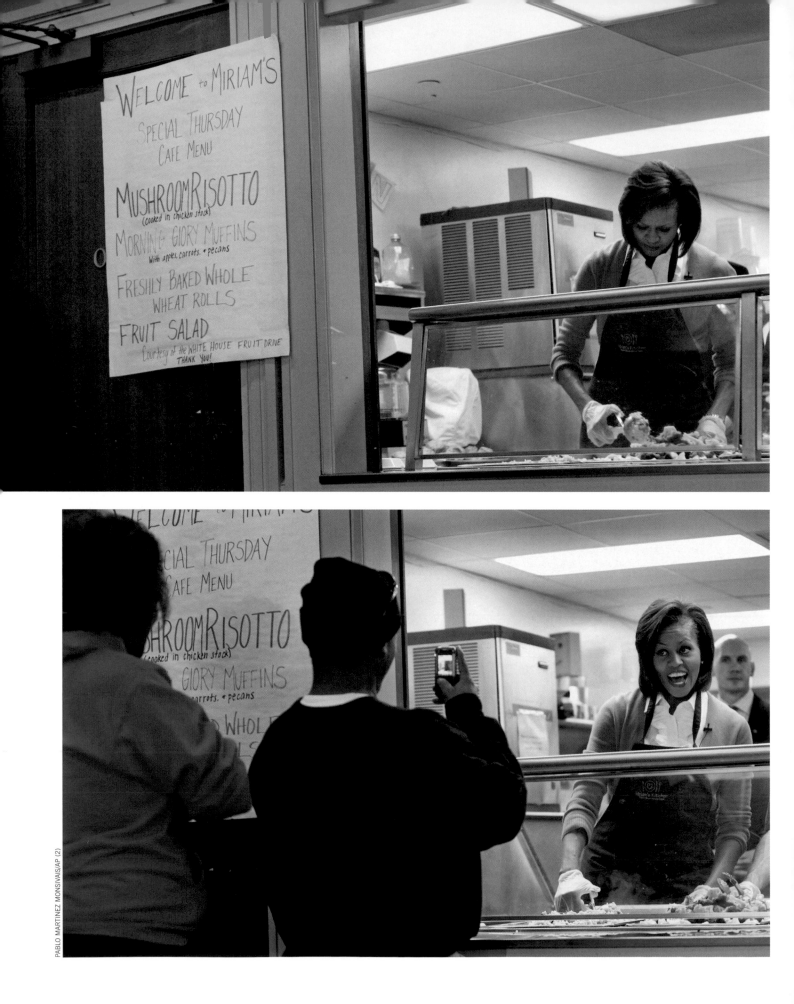

114

KRIS CONNOR/GETTY

Opposite: On March 5, 2009, Michelle works the lunch line at Miriam's Kitchen in the basement of the Western Presbyterian Church in Washington's Foggy Bottom neighborhood. Miriam's Kitchen has been serving warm meals to the homeless for 26 years. The First Lady plainly admits that she is not only enjoying getting out and about but is hoping to spur other volunteers. She says Americans, even those who can't afford to give food or money, need to focus on community service in this difficult period: "There is a moment in time when each and every one of us needs a helping hand. Miriam's Kitchen has become a place where so many people have been able to find that helping hand." Arriving with Michelle from the White House is a supply of fresh fruit that will support today's salad and supplement breakfast for the next two weeks. The First Lady's appearance at the kitchen goes largely unnoticed (top) and then . . . umm, not so much (bottom). The photo op is but a small moment in the dawn-to-dusk star turn that marks Michelle's initial weeks as First Lady. She is on numerous magazine covers and all over the celebrity columns. The mythmaking of this second iteration of Camelot—the perfect children, the perfect couple, the perfect public interactions perfectly orchestrated by a perfect White House promo machine—sometimes approaches the absurd. It is as if Michelle and Barack are idealized waxwork figures on display in a minutely imagined diorama at Madame Tussauds. Oh, yes, and that they are—as Michelle is unveiled in early April at the Washington branch of the kitschy museum (above). "Visitors will be able to admire the figure up close, as well as take photos with and even hug the Michelle Obama figure," Tussauds says in a press release. "Mrs. Obama is only the third First Lady to be immortalized in wax by Madame Tussauds Washington, D.C., joining two other iconic women who have served as First Lady." Any guesses on the other two? You're right: Jackie and Hillary.

Monday, March 2, is a snow day for the Obama girls, as an overnight storm dumps between five and eight inches on the nation's capital and shuts down just about everything (even Dad gets a short reprieve as the Federal Government opens two hours late). Elsewhere in town, the weather has created irony—hundreds of protesters on Capitol Hill demonstrate against global warming while being engulfed in the white stuff—but on the South Lawn of the White House, there is unalloyed, completely unironic joy. Since the Obamas hail from Chicago, where the winters can be brutal, they are well prepared with garb and gear— and even well-practiced technique.

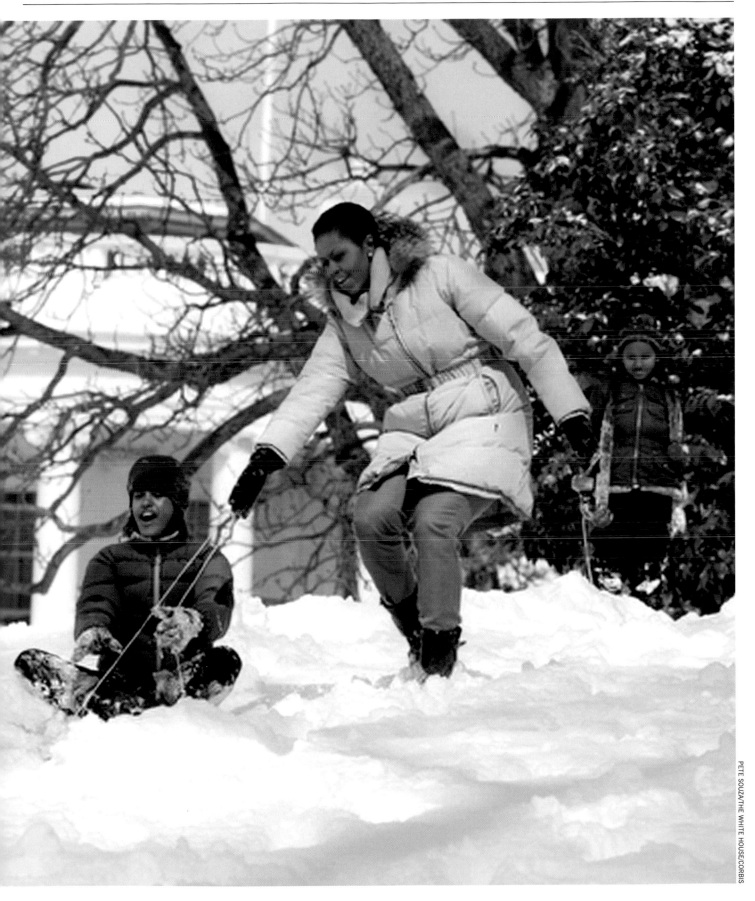

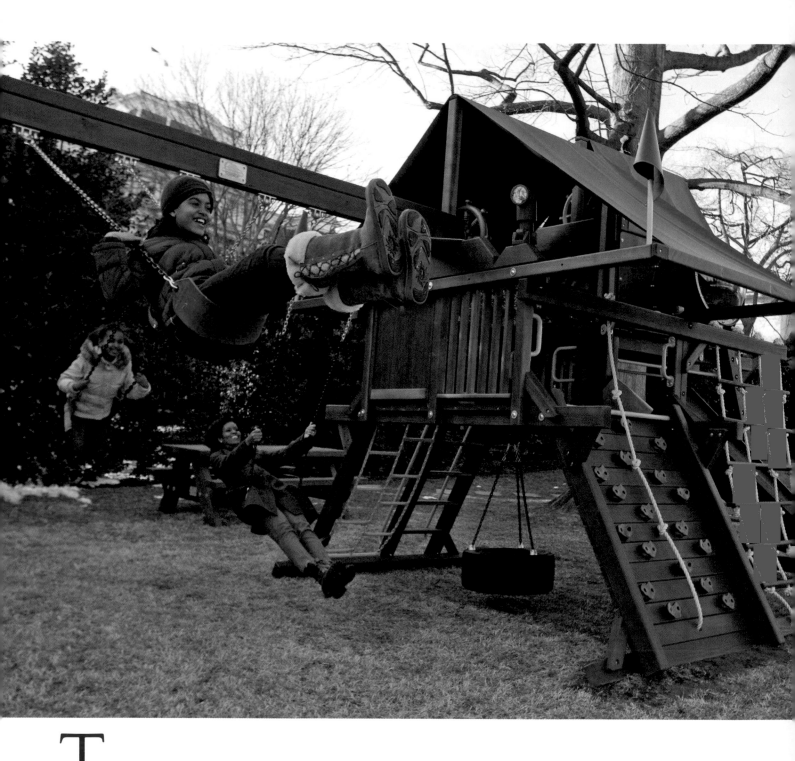

The snow has melted as quickly as it came, and on a chilly Wednesday, March 4, 2009, Sasha and Malia return from school to find that while they were away, their parents arranged for a new swing set to be installed on the South Lawn of the White House, within sight of the Oval Office. They squeal with delight, dash for the swings and (here joined by Mom) proceed to play for an hour. Many inhabitants of the White House have sought to customize the grounds for their families: The grandchildren of Franklin and Eleanor Roosevelt climbed on a South Lawn jungle gym, while Caroline Kennedy pushed her brother, John, on swings installed there in the early 1960s. Gerald Ford had a swimming pool put in; Jimmy Carter gave daughter Amy a tree house; George H.W. Bush had swings draped from tree limbs for his granddaughters. Two weeks after the Obamas' swing

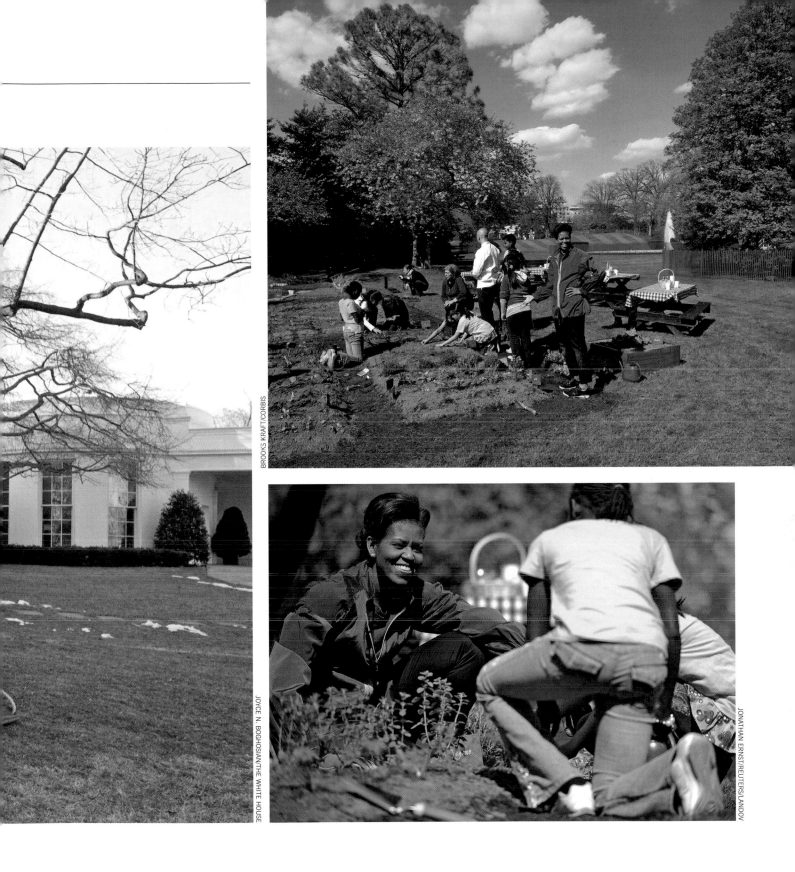

set is installed, Michelle announces on March 20, "This is a big day. We've been talking [about] it since the day we moved in." With that, she and two dozen fifth-graders from Bancroft Elementary School, plus Malia and Sasha, invade a plot of 1,100 square feet adjacent to the swings and create the first White House vegetable patch since Eleanor Roosevelt's World War II victory garden. In April, Michelle and the students return to plant

seedlings (above). After 40 minutes of work, she says that this session was a lot "easier than ripping the grass up." While much of the produce will find its way to the Obamas' table, the garden will yield "a ton of stuff," according to Michelle, and the surplus will be donated to Miriam's Kitchen. On the pages immediately following: More fun, as the President and First Lady host a 3-D Super Bowl viewing party in the White House theater.

On the White House grounds, there are sleds and swings and gardens. Inside, there are Super Bowl parties and, as we see here, celebrations and the affairs of state. Above: On February 25, 2009, Michelle speaks during an evening when Stevie Wonder is awarded the Library of Congress Gershwin Prize for Popular Song. The event has personal resonance for the First Couple. "Tonight it is a huge thrill for me as we honor a man whose music and lyrics I fell in love with when I was a little girl," says Michelle. "The first album I ever bought was Stevie Wonder's Talking Book. I'd go to my grandfather's because he was a real music junkie. He'd blast music throughout the house. And that's where he and I would sit and listen to Stevie's music together. Songs about life, love, romance, heartache, despair. He would let me listen to these songs over and over and over and over again . . . Years later, I discovered what Stevie meant when he sang about love. Barack and I chose the song 'You and I' as our wedding song." The President, following his wife, concurs with all sentiments: "I think it's fair to say

that had I not been a Stevie Wonder fan, Michelle might not have dated me. We might not have married. The fact that we agreed on Stevie was part of the essence of our courtship." Top: On March 11, after the President has announced the creation of a White House Council for Women and Girls, Secretary of State Hillary Clinton and the First Lady join to present the State Department's Award for International Women of Courage to seven female activists "who have fought to end discrimination and inequality." Secretary Clinton, in her remarks, salutes Michelle's "grace and wisdom" and calls her "an inspiration to women and girls not only in the United States but around the world." Michelle applauds Hillary in turn, citing her service and dedication to improving living conditions for women and girls. "As women, we must stand up for ourselves," the First Lady says. "As women, we must stand up for each other. As women, we must stand up for justice for all." In the bottom photo, Michelle is surprised on January 22 by a birthday party thrown for her by the White House staff.

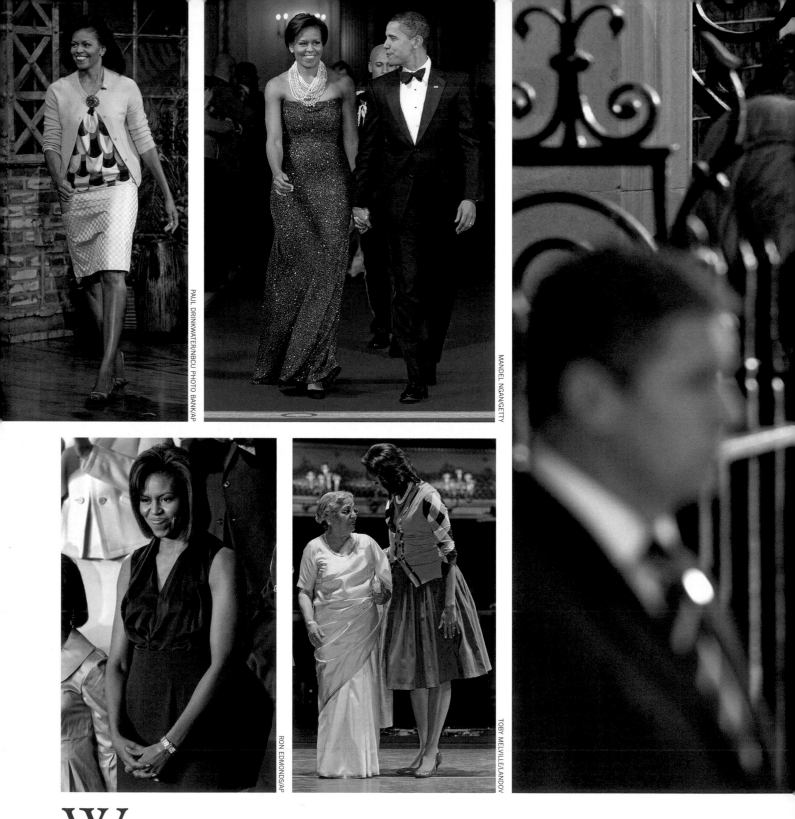

PAUL DRINKWATER/NBCU PHOTO BANK/AP

MANDEL NGAN/GETTY

RON EDMONDS/AP

TOBY MELVILLE/LANDOV

When the Council of Fashion Designers of America announced that its 2009 Board of Directors' Special Tribute would be awarded to the First Lady to honor her "inspiration and commitment to American fashion," the news could have been filed under: Duh. Long before the Council's formal recognition of Michelle, she had established herself as the country's—perhaps the world's—latest and largest style icon, the new Lady Di or Jackie Kennedy. The cover of The New Yorker's special issue on style featured a painting of three Michelles strutting on the catwalk, while across the pond, The Daily Telegraph of London proclaimed her "the mint-green queen of fashion." The queen's first splashes had been made with snazzy sportswear—some of it mint green indeed—as much as with elegant evening wear. The yellow ensemble at the top left represents her first famous fashion statement: After Sarah Palin's exorbitant clothing budget had become a hot topic during the presidential campaign, Michelle shows up on the Tonight Show on October 27, 2008,

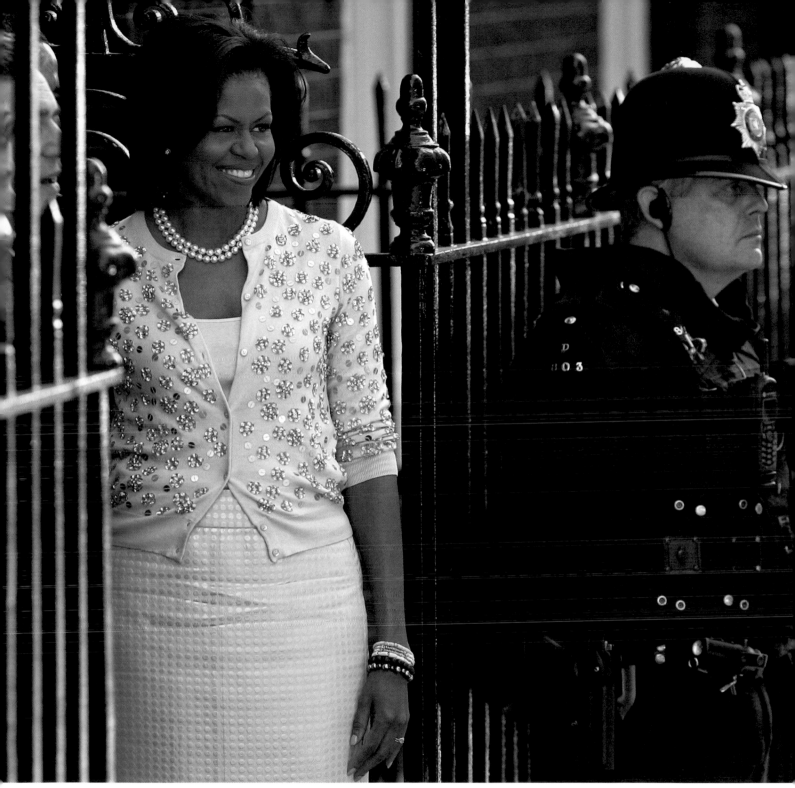

ensemble, explaining that it's from J.Crew and adding, "You can get some good stuff online." The total cost of the outfit is $305.99: $89.99 for the crystal-button cardigan, $148 for the Pembridge-dot pencil skirt and $68 for the silk Elizabeth halter. Moving clockwise from there on the opposite page, Michelle gets glammed up for a White House dinner on February 22, 2009, in a Peter Soronen gown and a necklace by Tom Binns; the First Lady and Gursharan Kaur, the wife of Indian Prime Minister Manmohan Singh, visit the Royal Opera House in London on April 2, with Michelle wearing a teal dress by Jason Wu and a cardigan by Junya Watanabe; and she attends her husband's speech to Congress in a sleeveless number by Narciso Rodriguez that inspires a wag in the press corps to nickname her arms Thunder and Lightning, like a boxer's. Above: On April 1, Michelle drops in on Britain's prime minister at 10 Downing Street, dressing just as she had when she appeared on Jay Leno—in a J.Crew cardigan and skirt.

In his first year as President in 1961, John F. Kennedy traveled to meet foreign leaders but was so thoroughly overshadowed during the tour by his glamorous wife that he was moved to joke: "I am the man who accompanied Jacqueline Kennedy to Paris." Forgive Barack Obama if he felt similarly eclipsed by Michelle when they made their initial diplomatic trip abroad as President and First Lady in early April 2009. "Why Doesn't the UK Have a Michelle Obama?" asked a London headline after the First Lady had captivated all of England with her grace, style and, yes, substance; at a London girls' school, she had dispensed hugs and advice: "The difference between a struggling family and a healthy one is often the presence of an empowered woman, or women, at the center of that family. The difference between a broken community and a thriving one is often the healthy respect between men and women who appreciate the contributions each other makes to society." There was some harrumphing among the elite (or the stodgy) that the queen is not to be touched upon her person (right)—never mind that cardigans are less than appropriate at Buckingham Palace—but all the queen's men pooh-poohed these quibbles, insisting that Elizabeth was positively charmed by Michelle. And so was British Prime Minister Gordon Brown, at their meeting in 10 Downing Street (opposite, top). Below: During the G20 summit in London, the statuesque Michelle stands, as usual, head and shoulders above most of the other women in attendance. Opposite, bottom left: Michelle's new bangs make a bang with the fashion press, as does this dress by Azzedine Alaia; the gentleman in the staid dark suit is Mr. Barack Obama of Washington, D.C. The European media was breathless in anticipation of a sit-down between Michelle and Carla Bruni-Sarkozy (bottom right), the former supermodel and singer who is now the wife of the French president and who has been, in recent years, the darling of the Continent—the new Diana. Reporting on the women's meeting in Strasbourg, France, the The Times of London expressed an opinion shared by many: "Carla who?"

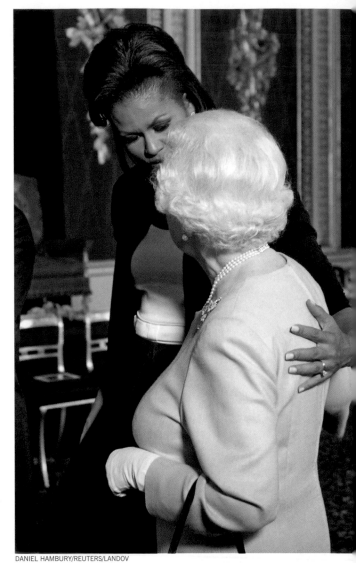

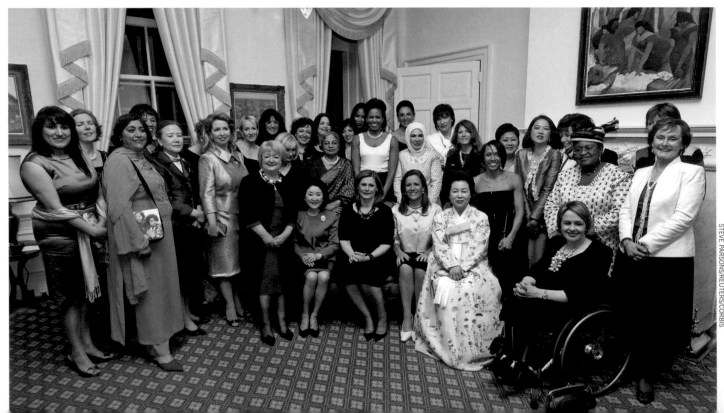

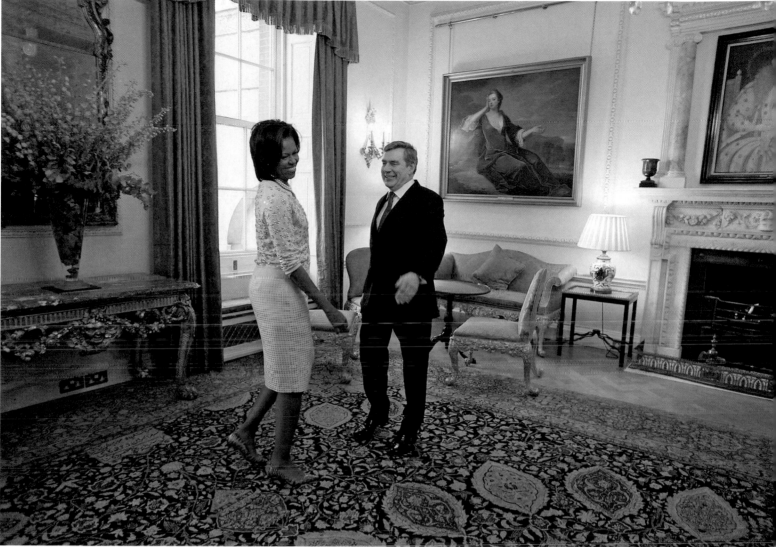

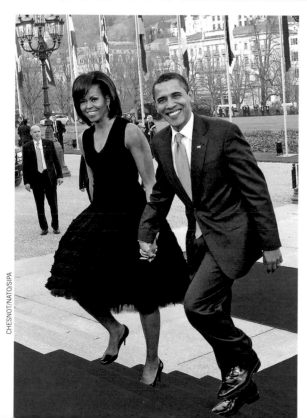

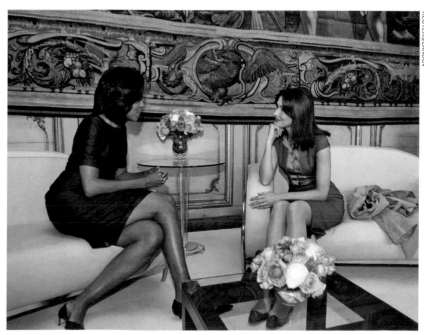

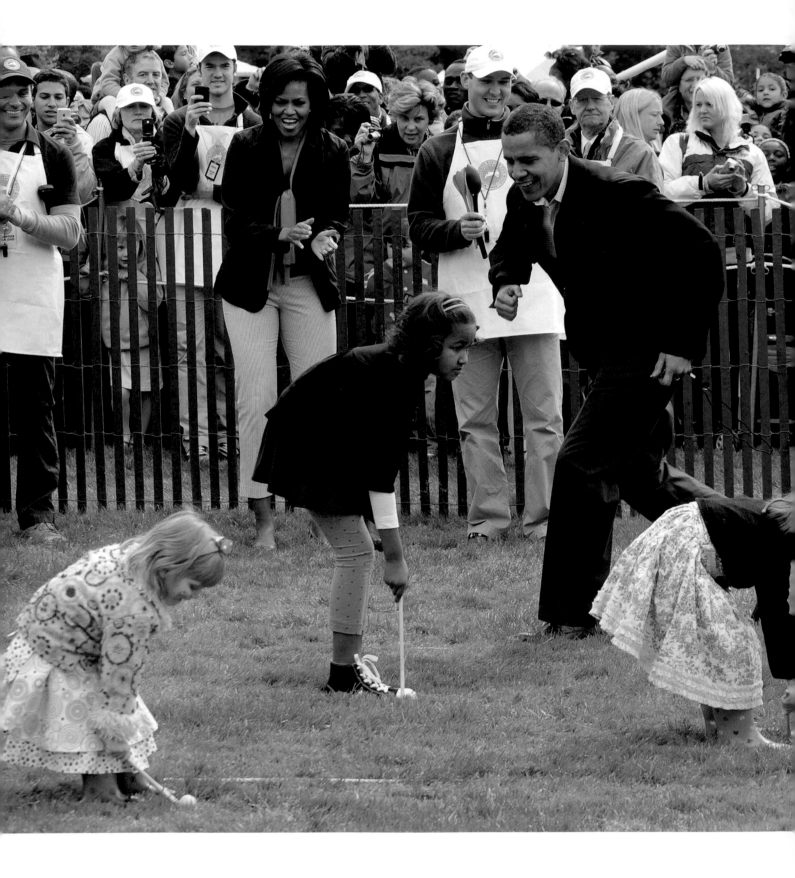

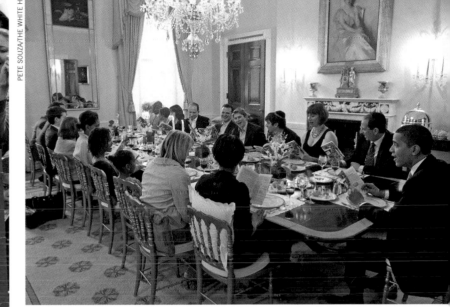

PETE SOUZA/THE WHITE HOUSE

ROGER L. WOLLENBERG/LANDOV

One of the several emphatic messages that the Obamas sent early on was that theirs would be an inclusive, ecumenical White House. The advent of spring's holy season provided an opportunity to drive this notion home. Above: Freshly back from a trip to Iraq, the President hosts on April 9, the second night of Passover, the first seder in the White House attended by the chief executive. The invitees are those who took part in an impromptu campaign-trail seder a year earlier, just before the Pennsylvania Democratic primary. Jewish backers applaud the event, even as some of them chafe that they weren't asked to participate. Left: Four days later, out on the lawn, Michelle and Barack are fully engaged in refereeing the annual Easter Egg Roll. (Sasha and Malia participate but diplomatically make certain that they do not win.) In addition to the egg roll this day, there is egg decorating, basketball, soccer, dancing, storytelling and yoga. The Obamas have made it a point that gay couples and their children are among the families invited to take part in these festivities. A postscript: The Obamas attended Easter services at nearby St. John's, but the White House hastened to release a statement saying: "The first family has not made a decision yet on which church they will formally join in Washington, but they were honored to worship with the parishioners at St. John's Episcopal Church."

Mrs. Robinson, too, comes to Washington. During the presidential campaign, Michelle's mother, Marian, had helped often with the children while remaining adamant that she would not be moving to the White House full-time. She had lived in Chicago her whole life and was happy there. "You've got to talk to Mom," Michelle said to Craig at one point. "She's not moving." Eventually Marian capitulated, saying she would come for a while to help the girls settle in. Since then, she has been enjoying her time in Washington to such a degree, she may stay for the duration. At age 71, she has been extremely active in her first months at the nation's executive mansion, shuttling the girls to school or playdates, helping them with their homework and taking them to White House functions (at right, in the East Room, they wait for Michelle to appear before a roomful of middle schoolers, to whom she will speak about African History Month; opposite, they head for the Easter Egg Roll, at which Grandma will pitch in by reading a story). Marian also makes sure to get out on her own. She patronizes local restaurants and is a fan of the cultural events at the Kennedy Center. She even accompanies her daughter on semiofficial social occasions, such as a lunch hosted by Teresa Heinz Kerry, wife of Senator John Kerry. "It seems to me that she's perfectly comfortable in this new life," the writer Sally Quinn, who met Mrs. Robinson at that lunch, told The New York Times. She went on to describe Marian as "the perfect grandmother you'd kill for: cozy, nice, sweet, friendly, dear." As a measure of just how comfortable Mrs. Robinson has become, when she bids the Obamas goodnight and heads for her third-floor bedroom, one flight up from their own, she says, "I'm going home."

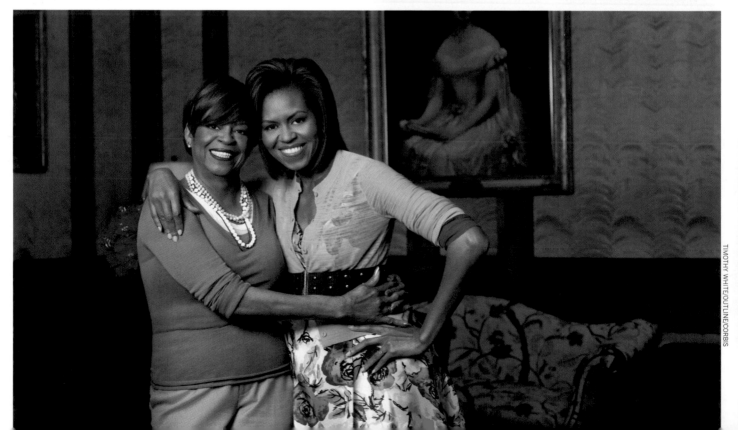

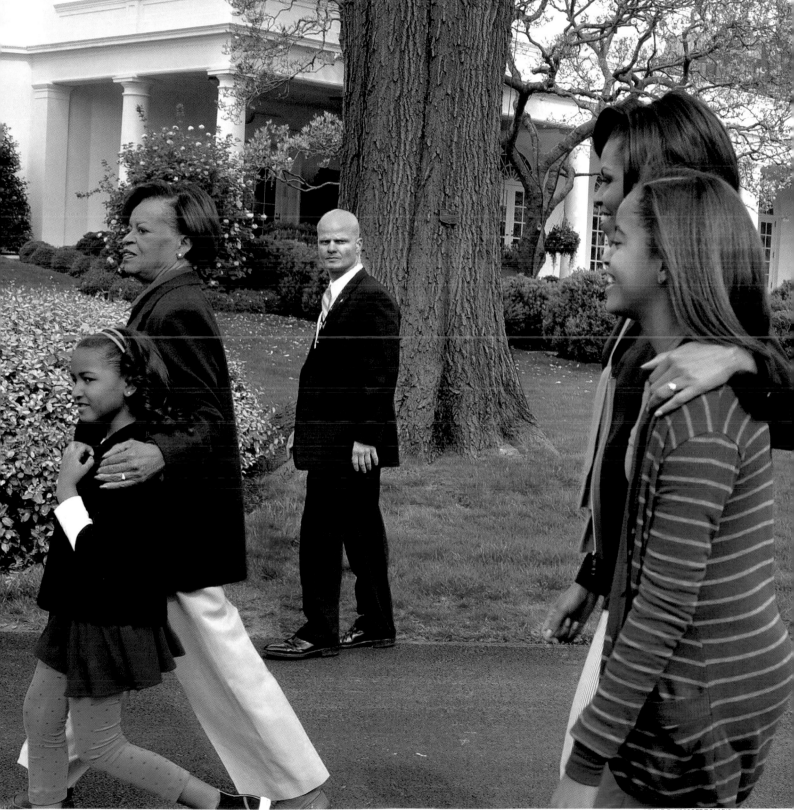

T here was all sorts of speculation as to why the Obamas chose Bo as the name for their 6-month-old Portuguese water dog, who officially arrived on April 14 as a gift from Senator Ted Kennedy and his wife, Vicki, to the Obama daughters. Our favorite of the numerous reasons offered— cousins had a cat named Bo, etc.—was that Michelle's father, Fraser, was nicknamed Diddley, and therefore both he and the rock 'n' roll pioneer Bo Diddley, who died in 2008, were being honored by the choice. The canine Bo brought to the show all the charisma and boundless energy that his namesake had once exhibited on stages across the land, and seemed just as comfortable in the spotlight. He was also a fine performer in less public settings. According to "sources," Bo had had to audition with the family at a top-secret assignation, known in the White House as The Meeting, a few weeks before being unveiled as The Dog to the wider world. He had passed that test with flying colors and will now spend his days in clover. South Lawn clover.

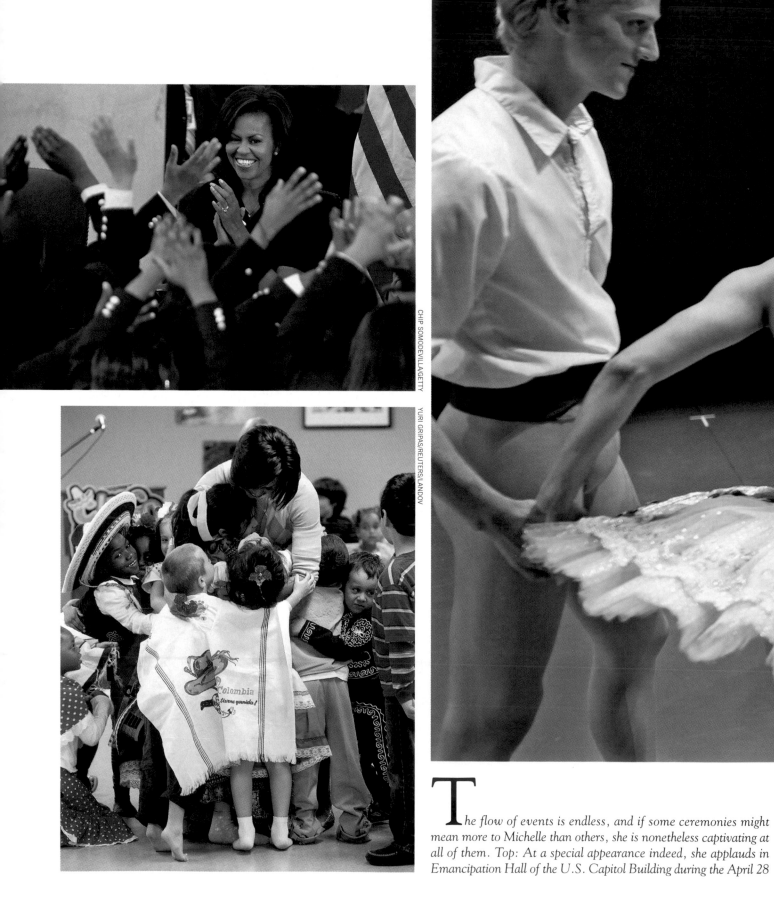

The flow of events is endless, and if some ceremonies might mean more to Michelle than others, she is nonetheless captivating at all of them. Top: At a special appearance indeed, she applauds in Emancipation Hall of the U.S. Capitol Building during the April 28

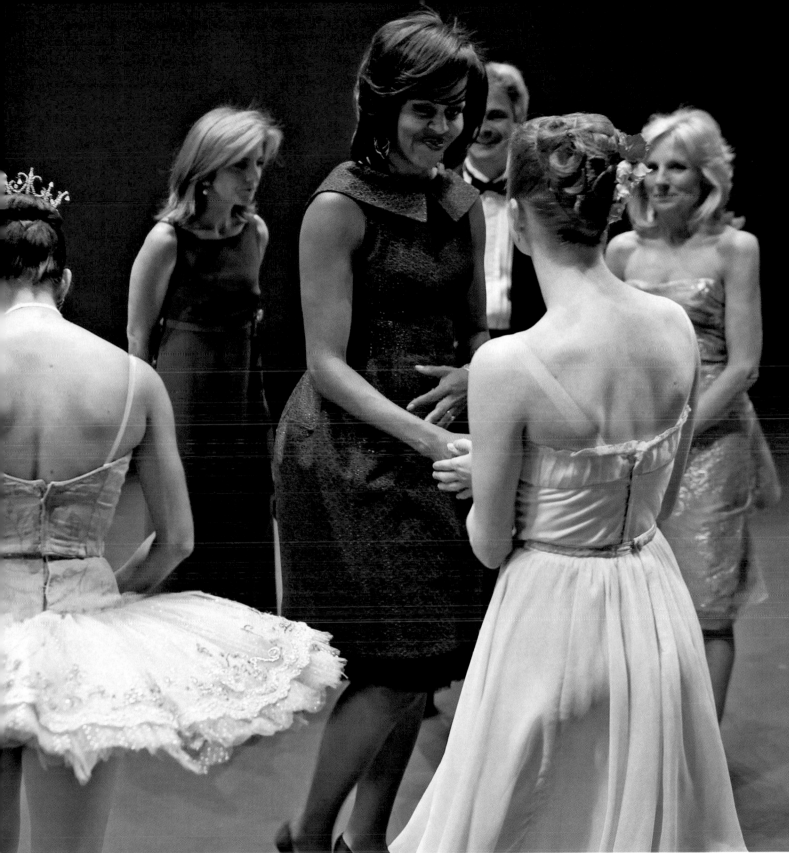

unveiling of a bust of the 19th century African American suffragist, abolitionist and former slave Sojourner Truth. Bottom: A week later, she visits the Lamb Public Charter School in Washington, D.C., to watch the children's Cinco de Mayo performances. Above: In New York City on May 18, along with Caroline Kennedy (behind Michelle, left) and Jill Biden, she attends the opening spring gala of the American Ballet Theatre, of which she is the new honorary chairperson. She's the new honorary something-person of a lot of things these days.

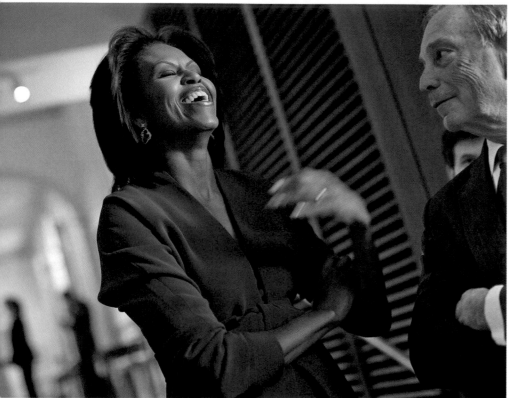

On this page we see two more pictures from Michelle's May 18 high-culture swing through the Big Apple. On the same day that she attends the ballet with Caroline Kennedy and Jill Biden, she is escorted to the Metropolitan Museum of Art by New York City Mayor Michael Bloomberg (left). Below: At the museum, she reviews the remarks that she will soon deliver as she cuts the ribbon at the reopening of the Charles Engelhard Court, centerpiece of the newly renovated American Wing. She tells the audience that she and the President are fully dedicated to the arts and to arts education in public schools. She also reminisces that her first date with Barack was at the Art Institute of Chicago, way back when: "You know, after 20-some-odd years of knowing a guy, you forget that your first date was at a museum. But it was, and it was obviously wonderful. It worked." It certainly did, and 20-some-odd years later (well, actually, 20 years exactly, since the date happened in 1989), the Obamas are still delighted in each other's company, as can be seen on the elevator to their private residence in the White House (opposite) after Barack has snuck a tortilla from a buffet table.

CALLIE SHELL/AURORA FOR TIME

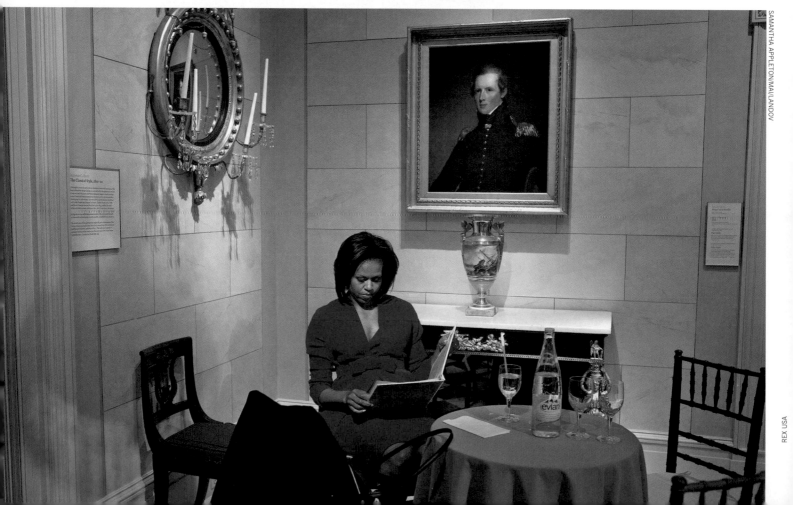

SAMANTHA APPLETON/MAI/LANDOV

REX USA

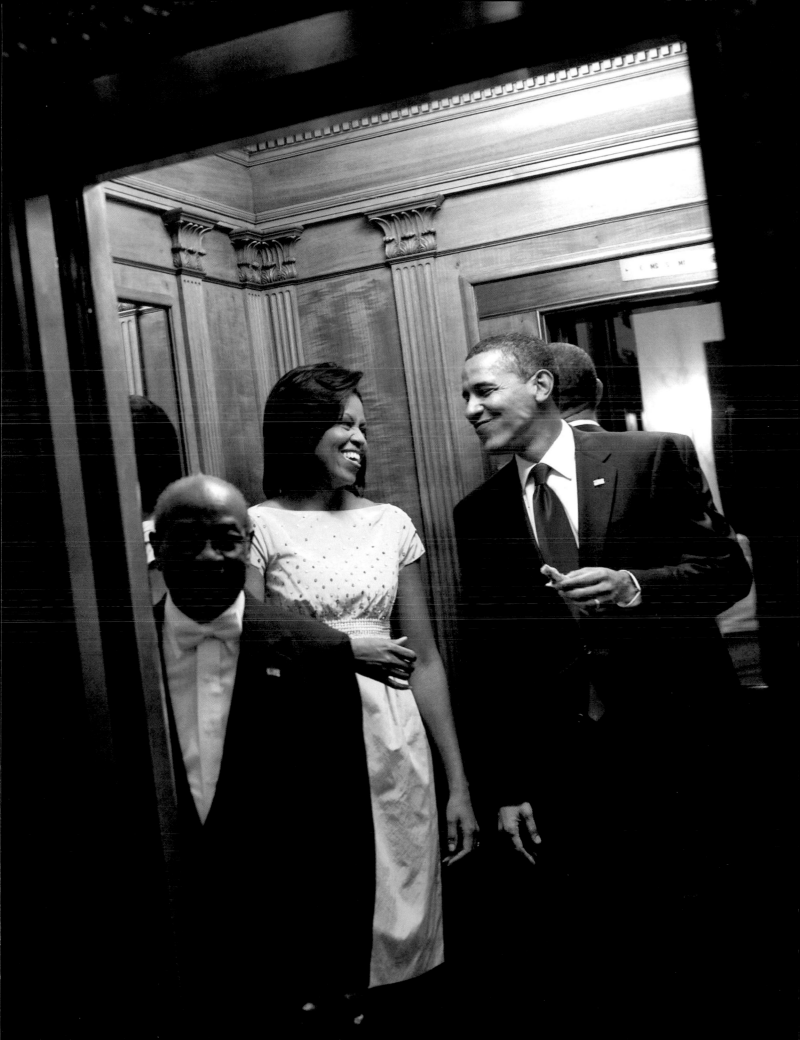

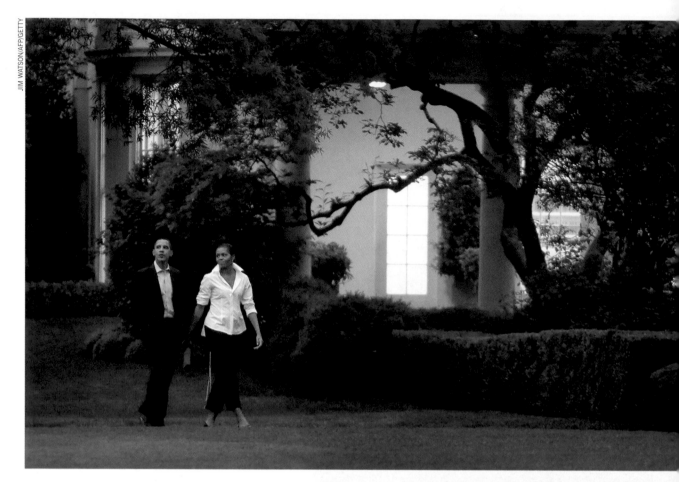

JIM WATSON/AFP/GETTY

Date nights for this happily married couple have become a bit more complicated. The good news is, they have Marian Robinson close at hand to babysit. The bad news is, when they go out, the whole world's watching. Above: On May 2, they walk quietly on the South Lawn after returning from dinner at the chic Citronelle in Georgetown. When they were discovered at the restaurant, a crowd of a few hundred people formed outside on M Street; police tape was used to keep the gawkers at bay, and meantime, a woman with a bullhorn started shouting, "This is so great that you are here!" Right: On May 30, the Obamas walk toward the Marine One helicopter at the beginning of a personal visit to New York City that will cause an even louder ruckus. On this evening, they dine at Blue Hill in the West Village, then head for midtown Manhattan, where they take in a play (opposite, the presidential limo outside the theater). Even before the curtain comes down, there are howls of protest from detractors who say it is unseemly for the First Couple to be gamboling at the public's expense during a recession. The Republican National Committee bothers to issue a news release chastising Barack for saying that he understands Americans' troubles, but then jets to New York for "a night on the town." Noting that General Motors is expected to file for Chapter 11 protection two days hence, the news release says, "Putting on a show: Obamas wing into the city for an evening out while another iconic American company prepares for bankruptcy." In his own statement, the President answers, "I am

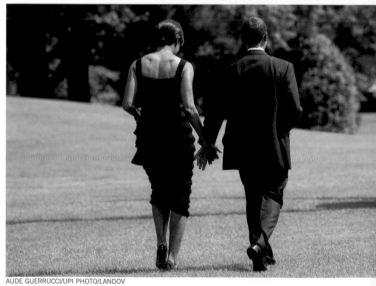

AUDE GUERRUCCI/UPI PHOTO/LANDOV

taking my wife to New York City because I promised her during the campaign that I would take her to a Broadway show after it was all finished." At the end of the day, it seems more Americans are happy for the lovey-dovey Obamas than are angry with them.

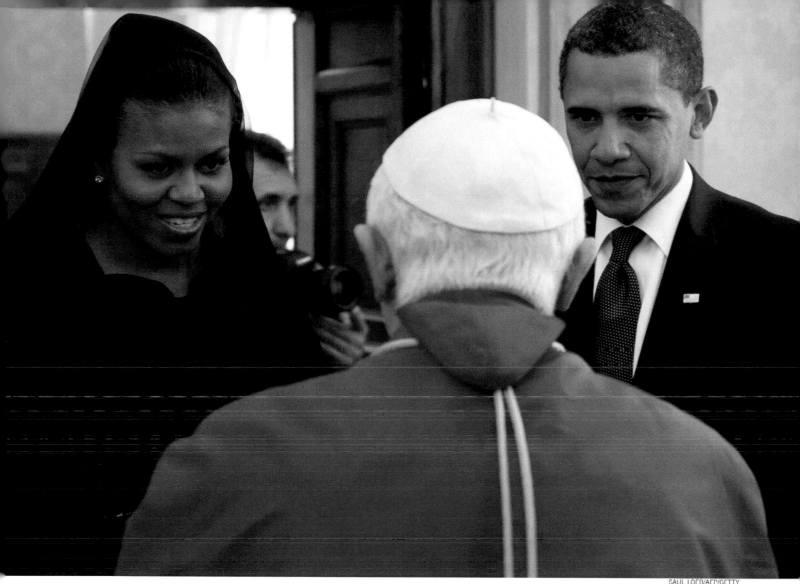

SAUL LOEB/AFP/GETTY

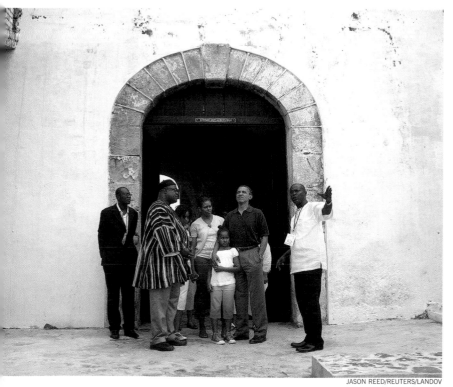

JASON REED/REUTERS/LANDOV

In mid-July 2009, the Obamas, including the girls, are off on an exotic, whirlwind, often emotional world tour. Clockwise from above: An audience with Pope Benedict XVI in the pontiff's private library at the Vatican; standing at the Door of No Return during a visit to the Cape Coast Castle, a former slave-holding facility in Ghana; meeting Russian President Dmitry Medvedev at the presidential residence in Gorki, outside Moscow; and visiting the St. Demetrius Nursing School at Moscow's Pervaya Gradskaya Hospital. Much was made in the press of Michelle's slave heritage during the family's stop in Ghana, and she and Barack say that this brief sojourn provided a particularly important experience for their daughters, who are being raised in privilege and, the parents feel, need to remember how cruel history has been to others. On the pages immediately following: Watching the fireworks over the National Mall on the Fourth of July. That an African American couple might be doing such a thing from the vantage of the White House is a remarkable notion that the Obamas hope their children fully apprehend. Only in America.

141

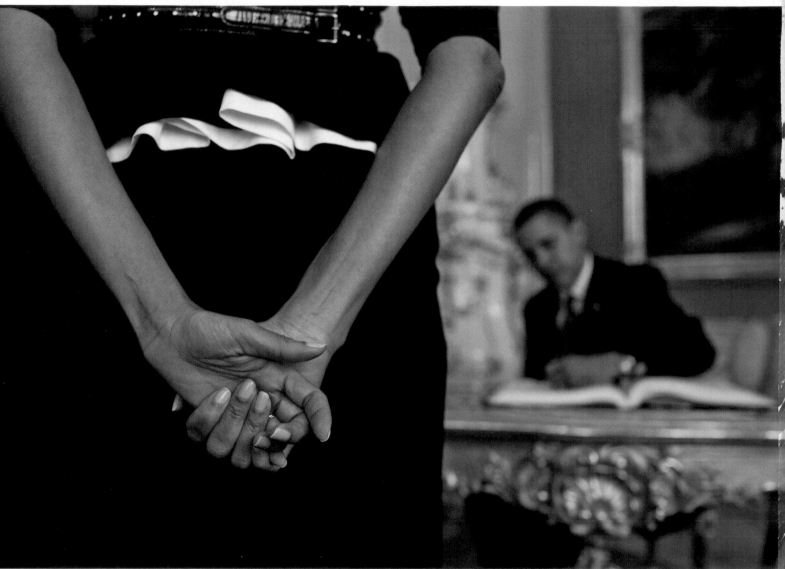

PETE SOUZA/THE WHITE HOUSE

Every First Couple since George and Martha Washington has brought a different dynamic to the presidency. There have been First Ladies who aspired to be the perfect hostess, others who hoped to inspire activism in the nation at large and still others who sought to help govern. Michelle Obama's role at 1600 Pennsylvania Avenue is only beginning to be formed, but no one doubts that it will be a substantial one. She has never not contributed. She has never not succeeded. She has never not excelled.